IMAGES
of America

TEMPLE TERRACE

Keep history alive —

Lana Burroughs

Tim Lancaster

GRANT RIMBEY

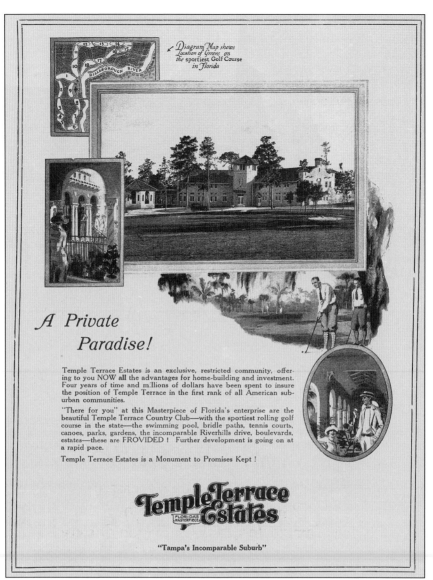

This advertisement is just one of many that were published in the early 1920s in newspapers and magazines throughout the country to promote sales of Temple Terrace property. The city was often billed as "Florida's Masterpiece" and "Tampa's Incomparable Suburb," and promotions touted amenities such as bridle paths, tennis courts, canoes, parks, gardens, and the sportiest golf course in Florida.

ON THE COVER: Professional golfers gather in front of the Temple Terrace Country Club clubhouse at the 1925 Florida Open golf tournament on February 24. In this photograph are, from left to right, (first row) James M. "Long Jim" Barnes, two unidentified, Roger Wethered (dark jacket, holding hat), Bill Mehlhorn, Gene Sarazen (with arms crossed), tournament champion Leo Diegel, Johnny Farrell (slightly behind Diegel), unidentified, J. Wood Platt (striped sweater), and the remainder are unidentified.

IMAGES
of America

TEMPLE TERRACE

Lana Burroughs, Tim Lancaster,
and Grant Rimbey with
The Temple Terrace Preservation Society

ARCADIA
PUBLISHING

Published by Arcadia Publishing
Charleston, South Carolina

Printed in the United States of America

Library of Congress Control Number: 2010925769

For all general information, please contact Arcadia Publishing:
Telephone 843-853-2070
Fax 843-853-0044
E-mail sales@arcadiapublishing.com
For customer service and orders:
Toll-Free 1-888-313-2665

Visit us on the Internet at www.arcadiapublishing.com

*We would like to dedicate this book to the residents of the city
of Temple Terrace, past and present. Without their courage,
faith, and vision, this unique community would not exist.*

CONTENTS

ACKNOWLEDGMENTS

We would like to thank the following for their ongoing support, encouragement, and efforts to preserve and protect the history of Temple Terrace: the Temple Terrace Preservation Society, city manager Kim Leinbach, Mayor Joe Affronti, city councilman Ken Halloway, city councilman Ron Govin, city councilwoman Alison Fernandez, city councilman Mark Knapp, city councilwoman Mary Jane Neale, Shirley Adema, George and Fran Barford, Jim Cole, Jack and D'ee Griffith, Geneva Meier, Frank B. and Marge Moses, Maud Pallardy, John and Doris Renick, Robert and Ann Simmons, Bob and Joanne Woodard, Temple Terrace Public Library, the Florida College Library, Lucy Jones of Historic Resources, LLC, and the USGA. A special thanks to the Temple Terrace Preservation Society board members who have recognized the value of this project, including Fell Stubbs, Leitha Bowles, Sharon Walker, Cliff Brown, and Brooks Marshall.

We would like to thank our editor, Lindsay Harris, for her guiding hand when needed.

Grant Rimbey: I would like to thank my wife, Susan, and sons, Pierce and Addison, for their support in my decade of acquiring Temple Terrace historical material, and my mother, Doris Rusch Rimbey, for her unwavering pride in Temple Terrace.

Tim Lancaster: My thanks go to Grant Rimbey and his dedication to the Temple Terrace community, and my wife Lana's perseverance throughout this project.

Lana Burroughs: I thank my husband, Tim, for his support and my mother, Inez McKissick Burroughs, for her legacy of compassion, kindness, style, and grace.

Unless otherwise noted, all Burgert Brothers photographs appear courtesy of Tampa-Hillsborough County Public Library Cooperative, Burgert Brothers Collection. Other images in this volume appear courtesy of the Grant Rimbey Collection of the Temple Terrace Preservation Society (GRTTPS), Lynn Elliott Collection (LE), Sarasota History Center (SHC), Historic Spanish Point (HSP), State Library and Archives of Florida (SFA), Jim Cole (JC), Joanne Woodard (JW), Temple Terrace Public Library (TTPL), Florida College (FC), Trinity College (TC), Fowler Family Archives (FFA), Library of Congress (LOC), John and Doris Renick Collection (JDR), Chicago Historical Society (CHS), History Miami (HM), and U.S. Geological Survey (USGS).

We are deeply indebted to the following sources: *Out of the Past*, by J. M. Jack Bregar; *Temple Terrace, The First Fifty Years*, by Cleo N. Burney; the *Tampa Tribune* and *Tampa Morning Tribune*; and the St. Petersburg *Evening Independent*.

More historic photographs can be seen at www.templeterracepreservation.com.

INTRODUCTION

The sleepy little town of Temple Terrace, Florida, unbeknownst to many, has quite a thrilling past. The city was built on a vision: a romantic notion of paradise in 1920. The largest exotic orange grove in the world . . . Spanish and Italianate villas of various hues and red-tiled roofs . . . a grand and picturesque river winding through a hilly landscape—the picture was well painted in sales brochures designed to appeal to anyone dreaming of a rustic and peaceful life, especially those northerners who were locked in a wintry freeze. The beautiful scenery was already in place. All that was needed to make paradise a reality was the right combination of designers, architects, artists, and planners, and, of course, businessmen.

The first person known to have recognized the special appeal of the untamed woodland came along between 1910 and 1914—long after the early Tocobaga Indians and later the turpentine and lumber companies and the first homesteaders. Bertha Palmer was lured to Florida from Chicago, made a home for herself in Sarasota, and discovered the area now known as Temple Terrace. She purchased 19,000 acres of land, named it "Riverhills," and turned the most attractive part of it into a hunting preserve and ranch. Palmer built a hunting lodge, servants' quarters, and other buildings, established a water supply capable of serving 500 people, and kept cattle and hogs. She brought friends and family to hunt in the woods, fish in the river, and enjoy the simple beauties of old Florida. Early in 1917, Palmer began selling off the rest of her properties in Tampa, but not Riverhills; it was thought to be her favorite.

No one knows for sure what Palmer's intentions were for her beloved riverfront sanctuary, and her untimely death in 1918 brought her direct involvement to an end. But questions linger about what she may have had in mind for the future. Coming to Florida on her own after her husband's death, Palmer was known to be a shrewd businesswoman and independent thinker and deeply involved in ranching, farming, growing citrus, and gardening in Sarasota. She was a world traveler and an art patron, loved the game of golf, and was related to royalty. Local historians believe that she was one of only a handful of people capable of the grandiose idea that came to life in Temple Terrace. And evidence indicates that the original vision was hers.

After Palmer's death, the Riverhills property was sold in 1920–1921. Soon a group of men—D. Collins Gillett, Vance Helm and B. L. (Burks) Hamner—formed a development plan. Palmer's brother, Adrian Honoré, was retained on the board of Temple Terraces, Inc., and Maud Fowler, a strong-minded businesswoman much like Bertha Palmer, took on a significant role in the project.

By 1921, a formidable roster of nationally prominent investors had been lined up, and work began on the Temple Terrace plan that was going to be, as Hamner described in a *Tampa Morning Tribune* article, "a veritable fairyland of beautiful homes, parks and playgrounds, winding boulevards lined with tropical trees and flowers, club houses, golf links and amusement fields of every description. Here will be the place to spend your vacations or make your permanent home and fish, hunt, motor, bathe, play golf, tennis or roque, ride horseback or indulge in any avocation your fancy

may dictate. And the best part of it all is that we shall plan it so that a temple orange grove will pay your bills."

Thousands of acres of land were cleared and planted with temple oranges. Construction began on a grand clubhouse, the golf course was laid out, and the first residences were built for the officers and directors in the development companies. An impressive sales force succeeded in bringing in busloads of potential buyers and investors daily from Tampa, St. Petersburg, and beyond. Maud Fowler's son, Cody, an attorney for the company and also a partner in the business, recalled one day when property sales totaled $1 million.

The 1920s were roaring, the Florida land boom was under way, and Temple Terrace was becoming the place to rendezvous for visiting celebrities and prominent Tampans. Club Morocco opened as the most luxurious nightclub on the west coast of Florida, according to some who were there, and the gambling casino was the scene of high-stakes wins and losses. World-class entertainment kept the crowds coming every night until midnight. The city was singled out by sports figures and society leaders as the most refined playground in Tampa. On any night, a person might be sipping champagne along with Babe Ruth, Connie Bennett, Al Jolson, or Red Grange to the tunes of the Club Morocco orchestra imported from Broadway and swaying to the songs of the French chanteuse Jeannette LaForest.

Just as suddenly, the bubble burst. By late 1926, the Florida real estate market had collapsed. Funding for the development of Temple Terrace was cut off, buyers defaulted on payments, and building stopped. In the winter of 1927, the final blow came when the exotic temple orange groves were wiped out by a freeze and then neglect.

A wealthy New York philanthropist and one of the largest investors in Temple Terrace, August Heckscher eventually stepped in and took over the project. Bonds were issued to help the city get by, but eventually when the interest could no longer be paid, residents banded together and bought out the bonds in return for property. By December 1940, the city's debts were finally paid off, and a bond-burning ceremony followed. The community celebrated—showing a dedication and resolve that would see the little municipality through the tough times of the Great Depression. When the fabulous Club Morocco building was in need of renovation, residents applied for Works Progress Administration (WPA) funds to repair it. Later on, it became city hall. The city council sat in sessions upstairs in the old casino, next to the gambling equipment that still stood in place as dusty reminders of the Jazz Age. The once magnificent clubhouse had been sold in 1932 to Florida Fundamental Bible School, and in 1945 it was purchased by what is now known as Florida College. Taking over five buildings, including Club Morocco, and 150 acres of land, the college became and still remains a fundamental part of the city today.

In the mid-1950s, new housing and subdivisions sprang up in and around the city. Although Henderson Field Air Training Base, located just a few miles away, was closed after World War II, some military families remained in Temple Terrace. Busch Gardens eventually took over part of the airfield, and when the University of South Florida opened nearby in 1956, the city became, and still is, the neighborhood of choice for many professors and university staff members.

Today life in Temple Terrace is not quite so exciting and glamorous as it was at the peak of that blazing arc of the 1920s, but remnants of the dream live on. The winding and hilly roads, the meandering golf course, the ancient river, the giant old oak trees, and the beautiful 1920s town plan all still exist within a charming neighborhood just right for living close to nature yet not too far from the big city. Some of the original Mediterranean Revival buildings have been lost, but many still remain, along with newer mid-century modern examples of distinctive architecture.

Poised to break ground in 2010 on the business section that never had a chance to materialize beyond two buildings completed in early 1926, Temple Terrace will finally have the downtown core that it has needed for so long. The architectural richness of the new Mediterranean Revival/ Spanish Colonial structures (based on the old) combined with the convenience of amenities located close by will add depth and texture to the community and help solidify its identity as it has evolved from that early romantic vision.

One

THE EARLY YEARS

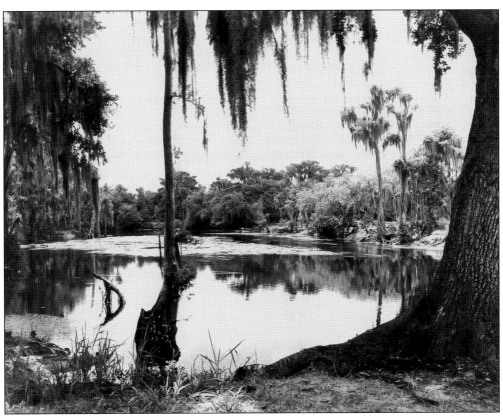

In the late 1700s, the Hillsborough River meandered through a rich, old-growth forest of majestic bald cypresses, longleaf pines, and sand live oaks that were hundreds of years old. From the mid- to late 1800s to about 1913, this old growth began to be logged, so that most of the trees within the Hillsborough River basin are now less than 100 years old. This photograph was taken just north of Temple Terrace.

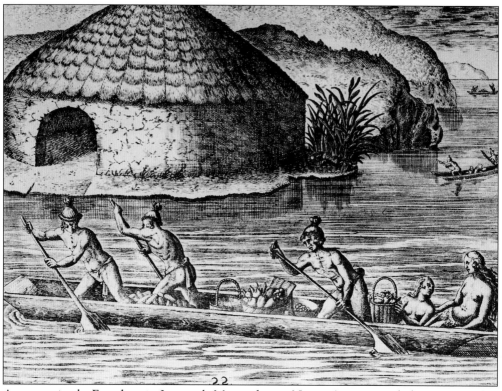

An engraving by French artist Jacques le Moyne depicts Native American inhabitants typical of those from the Temple Terrace area. The Tocobaga lived around Tampa Bay, both in prehistoric and historic times, until roughly 1760. Their diet consisted mostly of fish and shellfish. Le Moyne was a member of a famed expedition to the New World, and his illustrations of Native American life and plants are of significant historical importance. (SFA.)

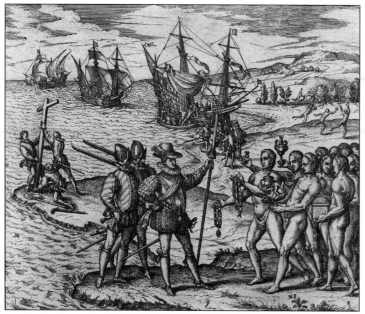

Spanish exploration of the area dates back to the 1750s. This engraving by Theodor de Bry depicts the first contact between a group of Europeans and Native Americans, and the Europeans can be seen erecting a cross. Don Francisco Maria Celi placed a similar cross upon landing in what is now Temple Terrace in 1757. (HM.)

Don Francisco Maria Celi erected a cross in what he named el Pinal de la Cruz de Santa Teresa (the Pine Forest of the Cross of Saint Theresa). A historic marker and a replica of the cross that was erected to honor St. Theresa on April 25 and 26, 1757, is found in Riverhills Park today. (GRTTPS.)

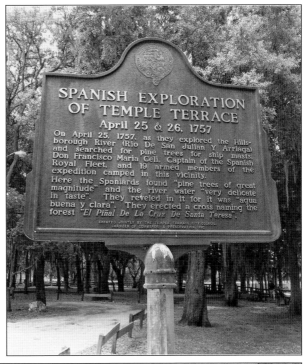

An early survey map of what is now the Temple Terrace area dates from 1843 and was signed on August 21, 1852. The survey was created to begin the transfer of federal lands to homesteaders. An extensive oak tree canopy is indicated along the river, and the rest of the land is a longleaf pine and wiregrass ecosystem. (USGS.)

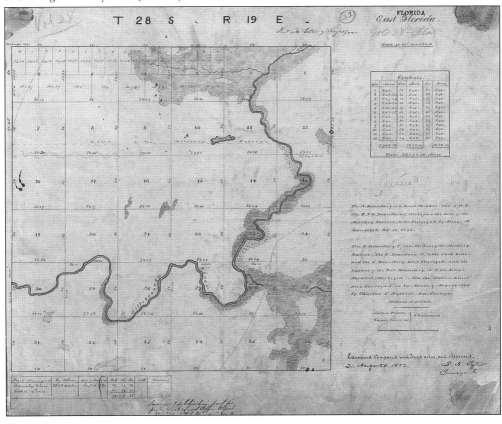

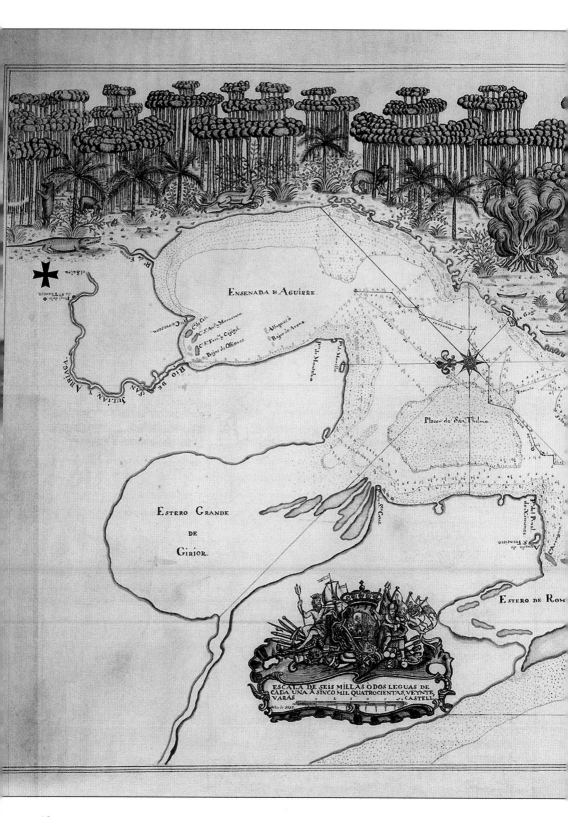

ENSENADA D AGUIRRE

ESTERO GRANDE
DE
GIRIOR.

Plazer de San Thelmo.

ESTERO DE ROM

ESCALA DE SEIS MILLAS Ô DOS LEGUAS DE
CADA UNA Á SINCO MIL QUATROCIENTAS, VEYNTE,
VARAS CASTELL

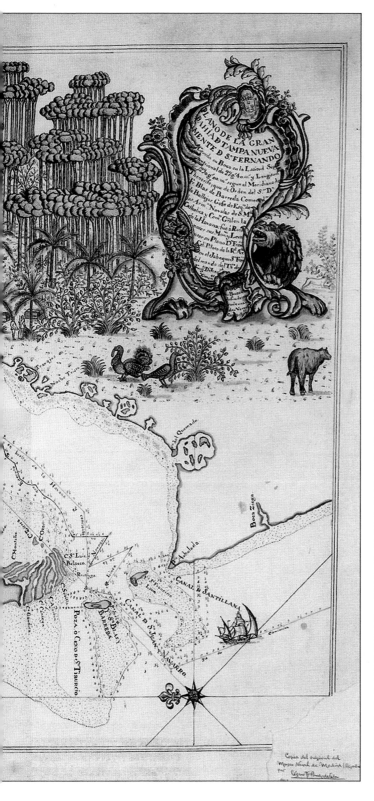

In 1757, Don Francisco Maria Celi, captain of the Spanish Royal Fleet, led an expedition into the area now known as Temple Terrace in search of pine trees to use as masts for his ships. This illustrated chart of his travels is the earliest known accurate map of the Tampa Bay area and depicts Celi's route along with illustrations of native vegetation and wildlife. The Hillsborough River, which he named el rio de San Julian y Arriaga, is seen at upper left. The area designated as el Pinal de la Cruz de Santa Teresa is now Temple Terrace. The rapids at Hillsborough River State Park, El Salto, is where the journey ended. The original Celi map is in the Museo Naval de Madrid, Spain, and confirmation of the fleet's travels is found in the map and logbook. East is oriented at the top of the page. The location of Temple Terrace is indicated with a cross at upper left. (GRTTPS.)

Before 1900, the Temple Terrace area was the location of turpentine camps, lumber companies, farming homesteaders, and early orange groves. Many turpentine camps cropped up throughout the region after the Civil War. Of those, some lasted for only a few years or until the pines were tapped out. Most trees were then cut down for lumber. The manual extraction of pine resin is a very labor-intensive process. (SFA.)

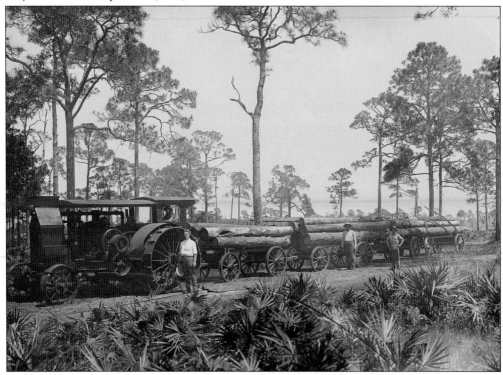

After Bertha Palmer's death in 1918, the Riverhills property was willed to her sons, who granted a five-year lease for $50,000 to the Lyon Pine Company. Local historians suggest there is evidence in today's tree canopy that logging occurred on a vast scale. This scene depicts a typical logging operation of the era.

Two

Bertha Palmer,
A Woman of Vision

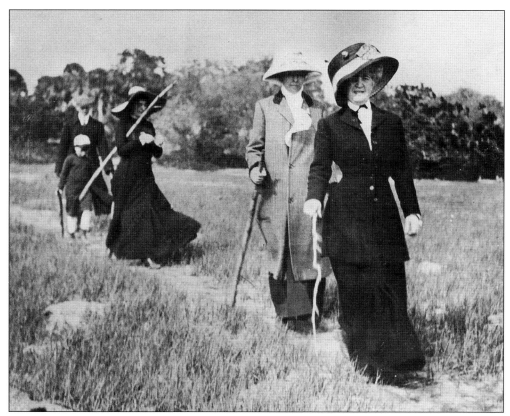

Bertha Palmer first visited Florida with her brother, father, and sons in 1910, and spent time touring Sarasota and the surrounding areas. Out for a walk on that first trip are, from left to right, Henry Hamilton Honoré (Palmer's father), Potter D'Orsay (Palmer's grandson), two unidentified, and Palmer. Within a year, she began purchasing what eventually became nearly 90,000 acres in the Sarasota-Venice area and around 19,000 acres in Hillsborough County. (CHS.)

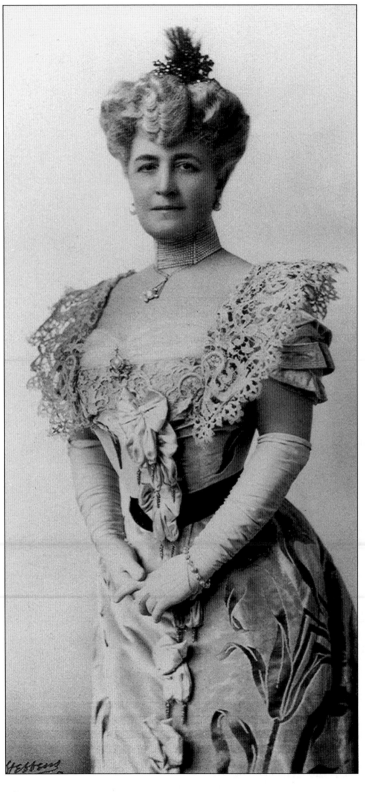

Bertha Palmer (1849–1918) was a world-renowned socialite, art patron, and businesswoman living an urban life in a Chicago mansion. After the death of her husband in 1902, she became entranced with Florida and headed south. Palmer set up her main residence in the Sarasota area, and she later purchased land in Hillsborough County where she established Riverhills around 1910 to 1914. It is known that she built at least two bungalows, a hunting lodge, and a few outbuildings and set up a water supply system large enough for a town of 500. Her ultimate plans for the area are yet to be documented, but her vast business, personal, and financial connections and her seemingly insatiable passion for exploration combined with a shrewd head for business make some historians believe she had a vision. A progressive rancher and land developer, Palmer was involved in the citrus industry and had a great love of golf. Evidence points to her early involvement in the golf course community and citrus grove development that would become Temple Terrace. (HSP.)

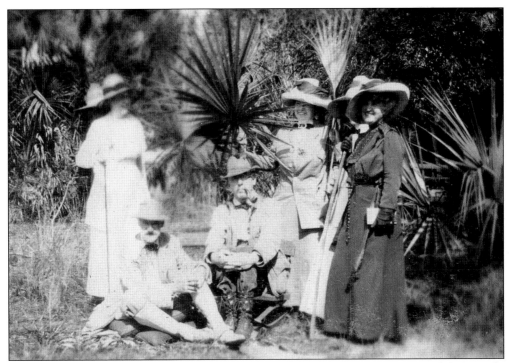

Bertha Palmer and family hold palmetto fronds in the Florida landscape in this undated photograph. From left to right are unidentified, Henry Hamilton Honoré (Palmer's father), Honoré (Palmer's son), two unidentified, and Palmer. (SHC.)

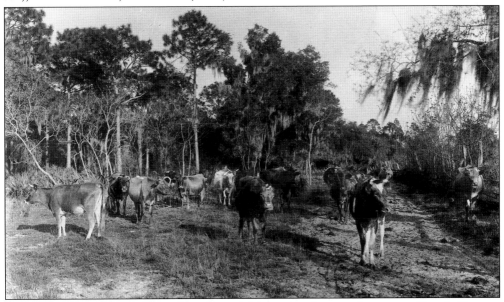

After establishing Riverhills ranch and game preserve in the area that is now Temple Terrace, Bertha Palmer kept hogs and cattle on the property, as evidenced in a 1917 letter (SHC archives) from her Tampa attorney H. G. Gibbons. Years later, cattle were still roaming the golf course and streets of the city, prompting an authorization to impound strays. The cows' hooves were causing heavy damage to the golf course greens.

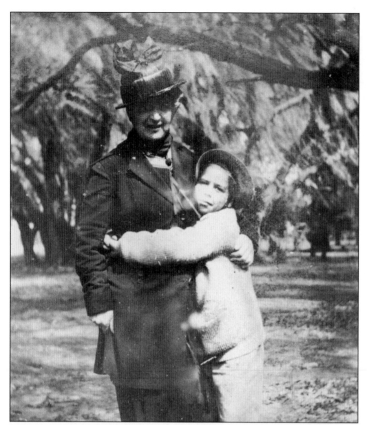

Bertha Palmer and her grandson, Potter D'Orsay, embrace in Florida around 1913. Palmer would have been about 64 years of age, and Potter D'Orsay, who was born in 1905, would have been eight years old at the time. (SHC.)

Potter D'Orsay (left) and an unidentified man (possibly a ranch hand) stop to pose for a photograph while out riding horses in Florida. The location is likely either Riverhills or Sarasota, around 1913. (SHC.)

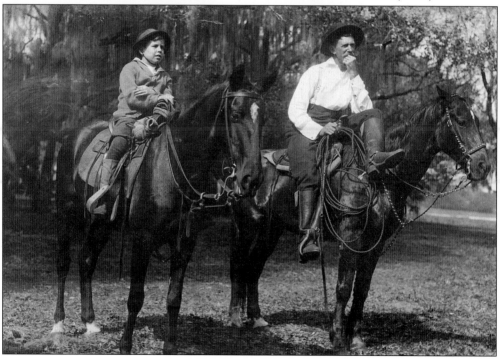

An unidentified woman with a shotgun is seen in this undated photograph, taken at one of Bertha Palmer's Florida properties, possibly Riverhills. The woman's formal attire, stylish hat, and polished boots indicate her stature in life. The man on horseback may be a ranch hand. Longleaf pines can be seen in the background. (SHC.)

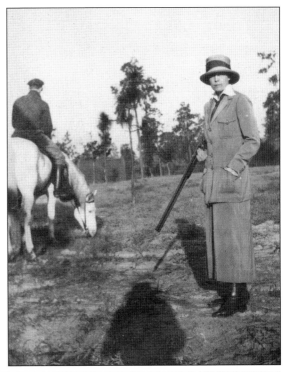

Palmer's game preserve was considered to be well-stocked and one of the most attractive hunting grounds in the state. Popular quarry at Riverhills would have included quail, dove, and turkey, for which hunters often used dogs. The swampy landscape in this 1920s photograph is typical for the Temple Terrace area.

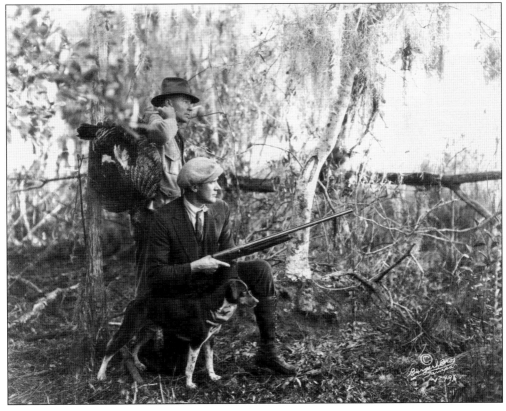

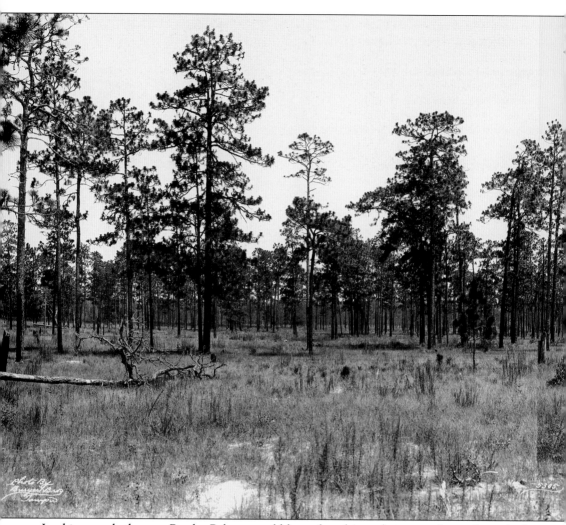

Looking much the way Bertha Palmer would have found it on her many forays through the area, this photograph of what is now known as Temple Terrace is dated June 1920 and depicts the original ecosystem of longleaf pine and wiregrass. Palmer was one of the largest individual landowners and developers in Florida at the time and had business dealings with D. Collins Gillett (an original developer of Temple Terrace) that have been established as going back earlier than February 24, 1917, as shown by a letter from Gillett to Palmer (SHC archives). Gillett references ongoing business dealings with Palmer's brother, Adrian Honoré, regarding selling off the property Palmer owned in South Tampa. Gillett also suggests teaming up with Palmer to purchase a tract of land together in north Hillsborough County. After Palmer's death, the property was eventually purchased by Gillett's group who proceeded to develop the land.

Originally a service building or stables, this structure was constructed around 1910 to 1914 by Bertha Palmer and is the last surviving building from that era. It was converted into a two-room schoolhouse in 1923, with grades one through six. Initial enrollment was 17 children with two teachers. Later saved from demolition by Ruby McSweeney and still later Marjorie Schine, it is now a community center known as Woodmont Clubhouse. This image dates from 1947. (JDR.)

The two cottages or bungalows seen here (the one at left is an H-shaped plan) were constructed by Bertha Palmer sometime between 1910 and 1914. Early newspaper articles reference a hunting lodge on the property, but the location has yet to be determined. They were acquired in 1944 by Florida Christian College (eventually Florida College). One was burned by arson in the 1960s, and the other was demolished in the 1970s. (TC.)

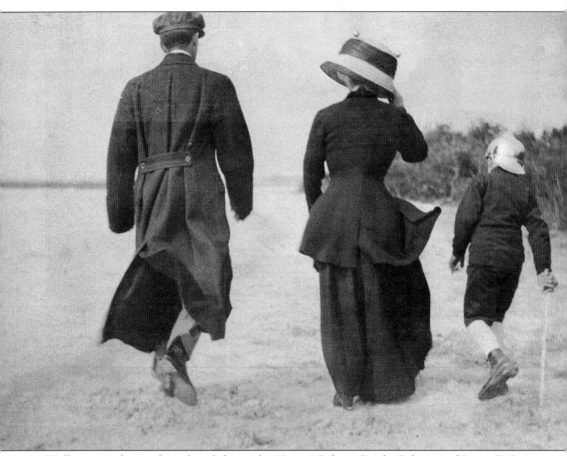

Walking into the wind are, from left to right, Honoré Palmer, Bertha Palmer, and Potter D'Orsay. Bertha Palmer and her son and grandson appear to be enjoying a winter outing in Florida, probably after 1911. A few years later, in February 1916, it was reported that Palmer would be attending the Gasparilla festival in Tampa along with such other prominent people of the time as Thomas Edison, James Whitcomb Riley, Andrew Carnegie, George Ade, and William Jennings Bryan. Since Palmer seemed most interested in her later years in spending her time productively, she likely would have attended the event in order to make connections with other leaders in business and the arts. After her premature death in 1918, her estate was split evenly between her two sons, Honoré and Potter Palmer II, who in turn sold her Riverhills ranch and game preserve to W. E. "Bill" Hamner. Hamner then sold the land to D. Collins Gillett, Burks Hamner, and Vance Helm who proceeded with developing the Temple Terrace golf course community and citrus groves. (CHS.)

Three

A City Emerges

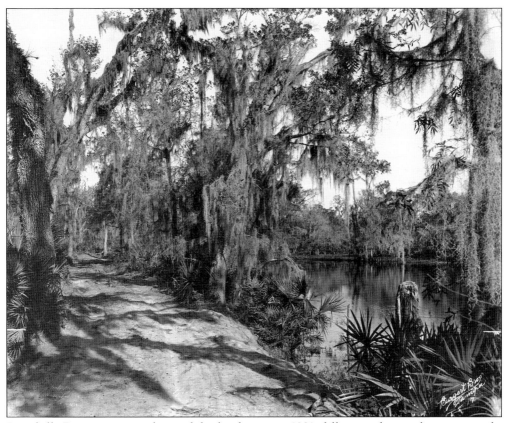

Riverhills Drive was carved out of the landscape in 1921, following the winding course of a 4-mile stretch along the Hillsborough River and opening up views to one of Florida's most attractive riverfronts. The boulevard passes along bluff after bluff, according to reports at the time, overlooking crystal water from 10 to 15 feet deep, amid unusual scenic beauty. (Photograph by Burgert Brothers; TTPL.)

Before clearing of the land began in 1921, the only roads in the Temple Terrace area were wagon ruts. The wild country, rich with hunting and fishing opportunities, was surely what attracted Bertha Palmer to the area—along with the natural beauty of the landscape. Her game and fishing preserve was intended to be maintained as part of the amenities of the future proposed development, and her hunting lodge was eventually reopened and furnished for use as a clubhouse and sales office for the first visitors who came to preview the property.

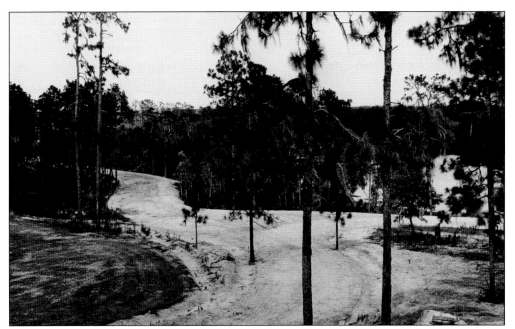

Riverhills Drive was named after the early Riverhills ranch and game preserve. These photographs of North Riverhills Drive show the first stages of clearing and road construction for the development of Temple Terrace. In the image above, to the left of the road, golf course hole 18 can be seen already well under way. A few months earlier, in July 1921, a secluded spot just upriver near Harney Road was the scene of a police raid when 5 gallons of moonshine and 200 gallons of mash were confiscated from two stills.

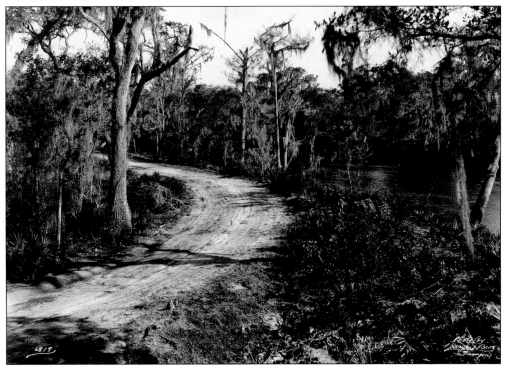

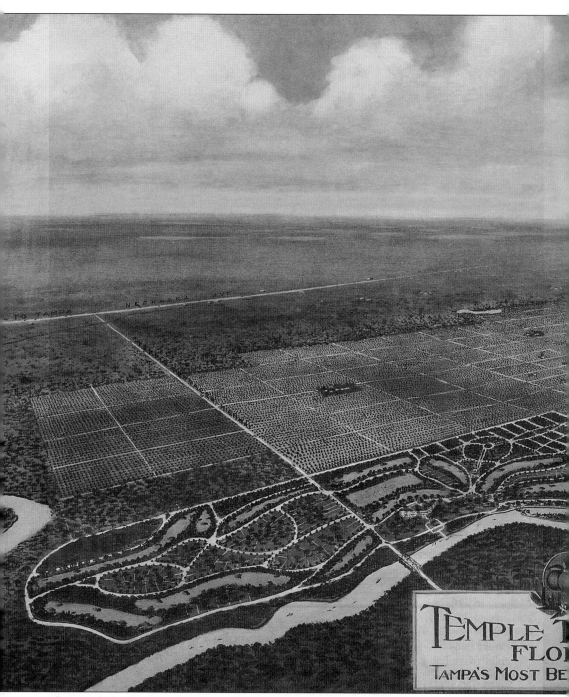

The grand plan for "Temple Terraces Florida—Tampa's Most Beautiful Suburb" is shown here in a recently discovered rendering based on an aerial photograph. This view highlights the immensity of the 5,000-acre temple orange groves to the west and north and the picturesque town and its placement around one of the most scenic bends in the Hillsborough River. The wooden bridge, where Temple Terrace Highway (now known as Bullard Parkway) crosses the river, can be seen near the top left edge of the center title plaque. Nebraska Avenue appears at the left edge of the map

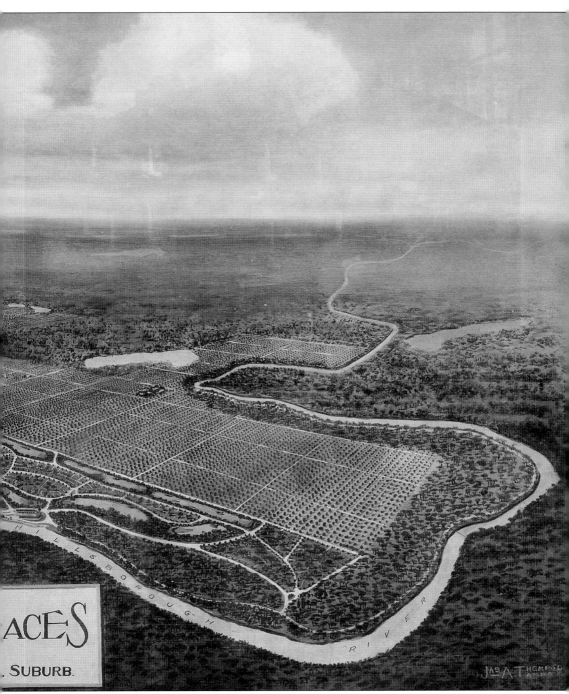

and disappears into the northeast horizon, and Fifty-Sixth Street is a small grove path that ends at the Hillsborough River. The planned Temple Terrace business district, which was included on the town plan layout, is not shown in this rendering. Also on this plan, the clubhouse is located on a site just south of its eventual location. Club Morocco was later built in the spot occupied on this map by the clubhouse. (GRTTPS.)

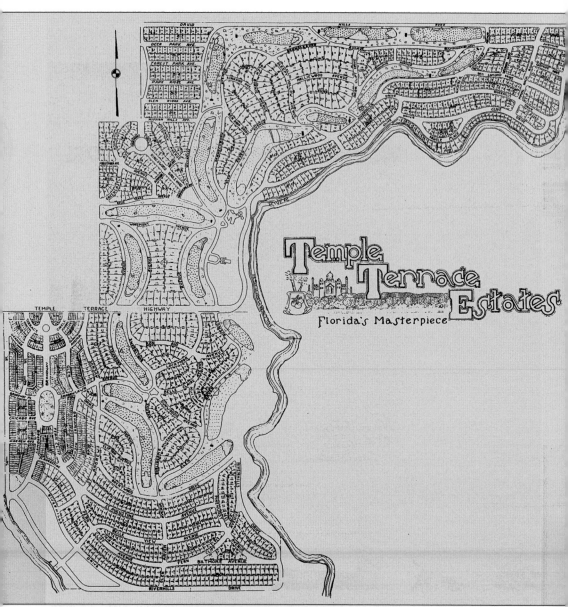

The organic concept of the Temple Terrace town plan was designed by George F. Young in 1920. Almost all of the residential streets exist today as drawn, although the city has, over the years, increased its physical size by incorporating nearby neighborhoods. The original northern boundary of the residential area was Druid Hills Road. The east boundary was Fifty-Sixth Street, and the south and west boundaries followed the river. The boundaries of the adjoining 5,000-acre temple grove oranges (not shown on plan) were Thirtieth Street to the west and Fowler and Fletcher Avenues to the north. The plan for the business district, at the intersection of Fifty-Sixth Street and Temple Terrace Highway, was fully conceived but never executed because the Great Depression halted construction. As can be seen, the main point of entry was an elegant arrangement of curved roads with a circular focal point leading to the main avenue, Broadway, which led to a large oval park in the center of the district. (GRTTPS.)

Landscape architect, civil engineer, and town planner George F. Young was born in Philadelphia, Pennsylvania, in 1880 and graduated from the University of Pennsylvania. After traveling to Tampa in 1913 for a railroad project, he soon relocated. In 1920, working with golf course architect Tom Bendelow and citrus grove developer D. Collins Gillett, Young designed the Temple Terrace master plan, which remains largely intact today. Young also planned Tampa's Davis Islands. (George F. Young, Inc.)

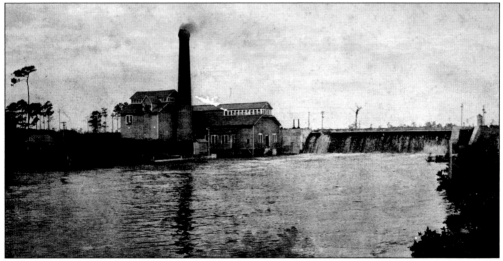

The Tampa Electric Company power plant and dam on the Hillsborough River, seen here around 1906, is located just downstream from the Fifty-Sixth Street bridge. The proximity of the power plant and ready availability of electricity played a part in Bertha Palmer's decision to purchase property nearby. (FSA.)

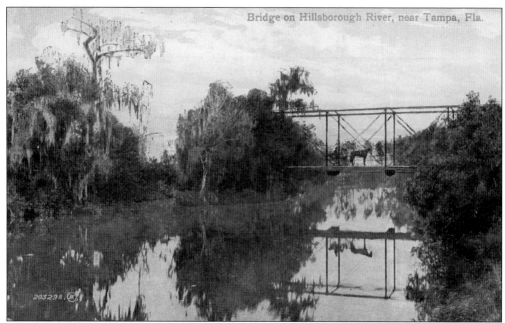

An early photograph of the Hillsborough River was turned into this scenic postcard. A horse and cart paused midway across the wooden bridge on Temple Terrace Highway adds to the bucolic scene, conveying a strong sense of nostalgia for another way of life from years gone by. (GRTTPS.)

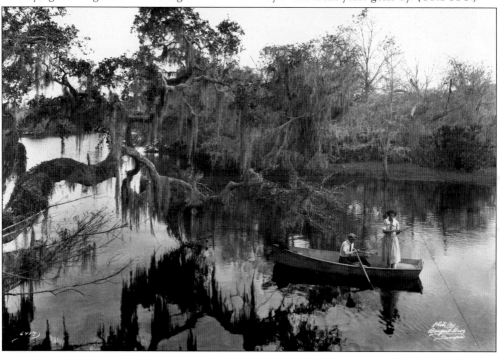

An unidentified man and woman enjoy a tranquil day of fishing on the Hillsborough River in Temple Terrace, as seen in a photograph from the early 1920s. The river, for the most part, is a dark or black water river, the water stained reddish-brown by tannic acid that comes from decaying leaves and other vegetation.

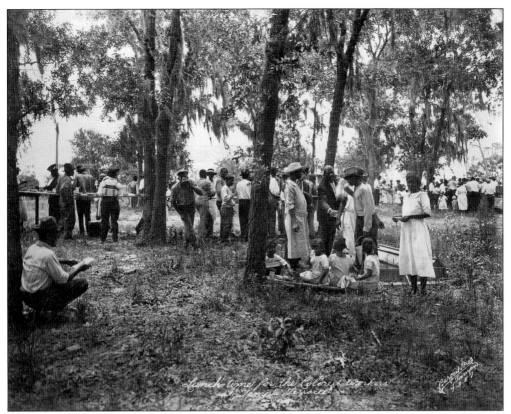

"Lunchtime for the Colored Workers at Temple Terraces" is inscribed on this photograph from the 1920s. Tables are set up under the shade of moss-draped oaks near the river. Most of the African American workers in Temple Terrace at that time lived in nearby Sulphur Springs. Many were employed as construction laborers and servants or worked as caddies on the golf course. (Photograph by Burgert Brothers; JW.)

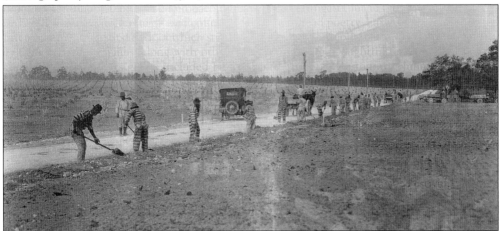

In this era, convicts often labored on the roads and highways of the nation. Men, mules, and wagons are hard at work in April 1922 on Temple Terrace Highway, shown here west of Fifty-Sixth Street. Rows of one-year-old orange trees can be seen marching right up to the roadside. The white sandy soil was the inspiration for the naming of Whiteway Drive, a local thoroughfare.

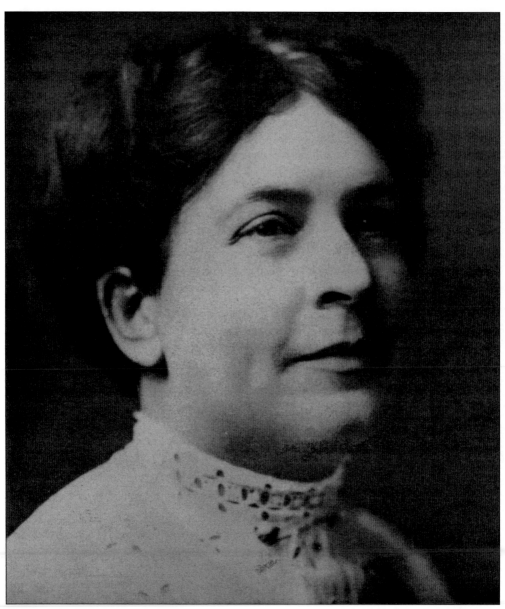

Maud Fowler (1874–1941), considered one of the foremost female real estate operators in America at the time, was one of Tampa's first prominent businesswomen. She moved her headquarters to Temple Terrace from Kansas City around 1920 for closer oversight of the Temple Terrace project. Considered a woman ahead of her time, Fowler soon became a pivotal figure and officer in the development company. The directors of Temple Terraces, Inc., included influential business leaders from New York City and across the country, and Fowler was vice president of the board and one of the largest stockholders. She and D. Collins Gillett helped incorporate Temple Terrace as a municipality, and both were named city commissioners in 1925; Gillett was elected as the first mayor, and Fowler became the first vice mayor-commissioner. She considered one of her finest achievements to be the establishment of Fowler Park, a Girl Scout camp in Kissimmee. The 6-foot-tall Fowler was a commanding presence known for her integrity and kindness. Fowler Avenue is named for the Fowler family. (GRTTPS.)

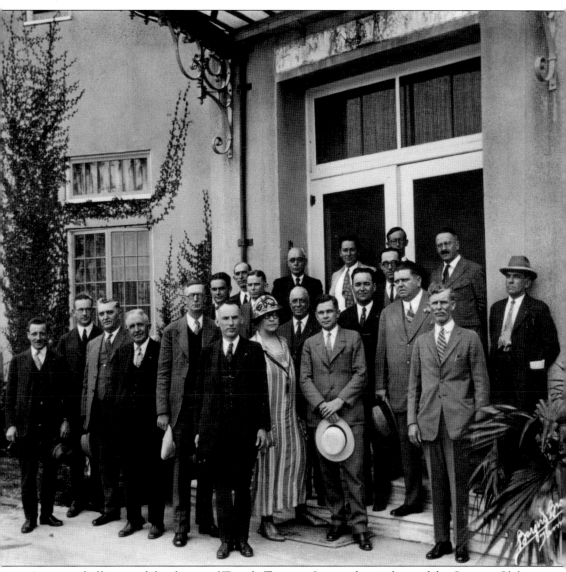

A group of officers and developers of Temple Terraces, Inc., gather in front of the Country Club clubhouse entrance on February 28, 1925. Shown are, from left to right, (first row) six unidentified men, Maud Fowler (in striped dress), three unidentified men, D. Collins Gillett, Carlton Cone (in front, with mustache), and unidentified; (second row) two unidentified men, R. D. Hoyt (a commissioner and city manager of Temple Terrace, seen behind Fowler's hat), and the remainder are unidentified. Directors of the corporation also included August Heckscher (New York City philanthropist and investor), Conrad Hubert (of New York City), Adrian Honoré (Bertha Palmer's brother), Barron Collier (New York City capitalist), Vance Helm (Miami developer), Col. James Frazer (former member of the war crimes board in Washington, D.C.), and George W. Crawford (of Pittsburgh). (Photograph by Burgert Brothers; TTPL.)

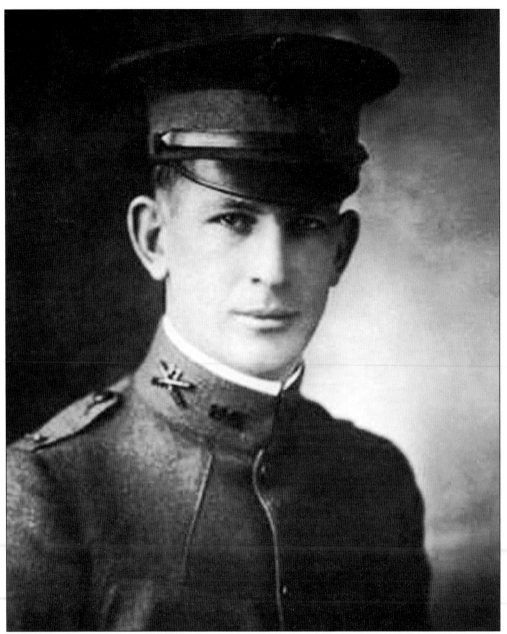

Orin Cody Fowler (1892–1978) was the son of developer Maud Fowler, who moved to Temple Terrace from Kansas City to work more closely with the Florida project. Cody Fowler was born in Arlington, Tennessee, and named for his relative, the famous scout and showman Buffalo Bill Cody. After serving as an artillery officer in World War I, Fowler became the first city attorney for Temple Terrace in 1925 and was voted mayor-commissioner in 1926. He was elected president of the American Bar Association in 1950, chaired the Tampa Bi-Racial Committee in the late 1950s and 1960s, and received the National Brotherhood Award from the National Conference of Christians and Jews for distinguished service in the field of human relations. Fowler's Tampa law firm, Fowler White Boggs, still operates today, and his onetime residence, now known as the Cody Fowler House, still stands. (FFA.)

Vance W. Helm, secretary and treasurer of Temple Terraces, Inc., moved from Los Angeles, where he found success in sales, to Miami, where he turned his focus to land and real estate. Helm became a pioneer in Everglades development and president of Everglades Sugar and Land Company. Owning a large tract of land in Davie, he and a group of men took on the monumental task of draining the Everglades, with the idea of turning a supposed liability into an asset. Helm was director of the Miami Chamber of Commerce, secretary of Florida First Commission, and copromoter (with D. Collins Gillett) of the Tamiami Trail. In 1921, in partnership with Gillett and Burks L. Hamner, Helm purchased the former Palmer ranch and game preserve in Hillsborough County, and the group formed two corporations: Temple Terraces, Inc., would develop the temple orange grove project, and Temple Terraces Estates would develop the residential golf course community. Helm lived adjacent to the palatial Deering estate, Vizcaya, on Biscayne Bay in Miami. (Thomas G. Carpenter Library, University of North Florida.)

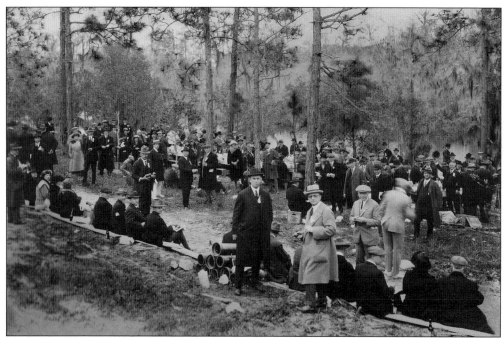

A crowd of real estate speculators converge along the Hillsborough River in the early 1920s. Aggressive advertising campaigns were carried out to sell homes and property in Temple Terrace. With sales offices across the country, the company had fleets of automobiles and buses constantly arriving with prospects. Those who traveled by train were bused in to stay at the clubhouse-hotel, play golf, and look over available property. (Photograph by Burgert Brothers; GRTTPS.)

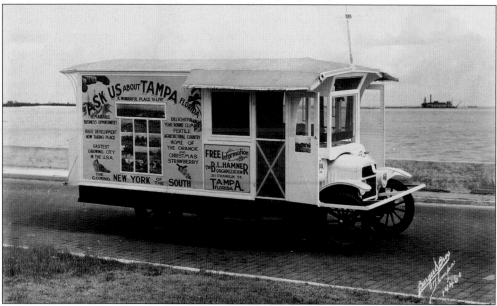

The B. L. Hamner organization was actively involved in promoting the community of Temple Terrace. On June 11, 1925, this truck advertising Tampa as "The Coming New York of the South" cruises Tampa's Bayshore Boulevard. Photographs of the Club Morocco swimming pool and the Temple Terrace orange groves are displayed on the side panels of the truck.

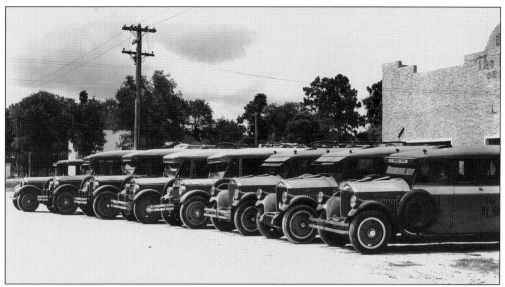

A fleet of tour buses is seen here at the B. L. Hamner Realty Corporation garage in a photograph dated July 19, 1926. Burks Hamner's buses shuttled tourists and speculators to his various developments, including Temple Terrace. He was a leader in some of the principal real estate and development enterprises in Tampa and the vicinity.

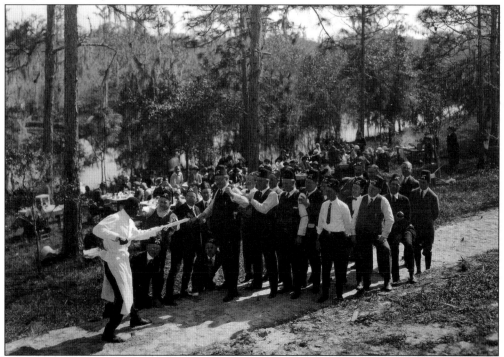

A group of Tampa Shriners engages in a jovial battle with a worker at the Temple Terrace Country Club. In 1921, upon accepting an invitation from Vance Helm to visit the community, the Shriners listened to his review of the remarkable progress made in the development. Helm declared that the company asked nothing from the visitors but their moral support. (Photograph by Burgert Brothers; GRTTPS.)

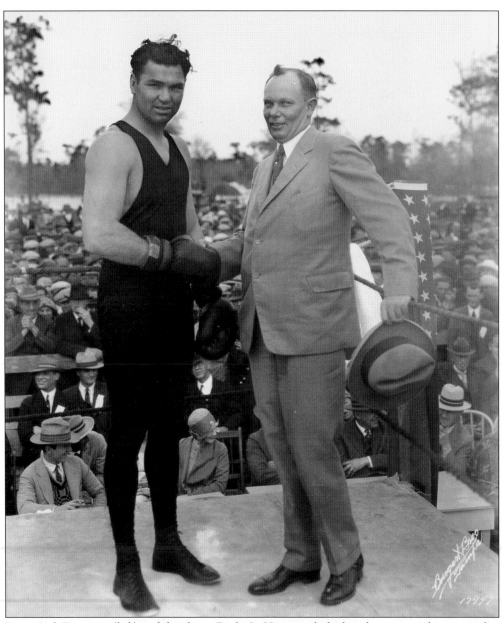

Boxer Jack Dempsey (left) and developer Burks L. Hamner shake hands in an outdoor ring after a local promotional fight on February 4, 1926. The "Manassa Mauler" held the heavyweight championship title from 1919 to 1926. Hamner was first vice president of Temple Terraces, Inc., and was instrumental in bringing the boxing legend to Temple Terrace as a way to promote the new development. Hamner started out delivering newspapers in Kansas City and later practiced law. After moving to Tampa, he became one of the largest individual grove and farm owners in Florida and was involved in various business interests. He was joint owner of Hamner and Evans warehouses in Jacksonville, vice president of Florida Orange Growers Corporation, president of Grapefruit Growers Association of Florida, director of the Florida-Carolina Fruit Company, vice president of Florida Finance Corporation, director of East and West Coast Railroad, vice president of Southern States Cattle Company, and secretary of the Tampa Board of Trade.

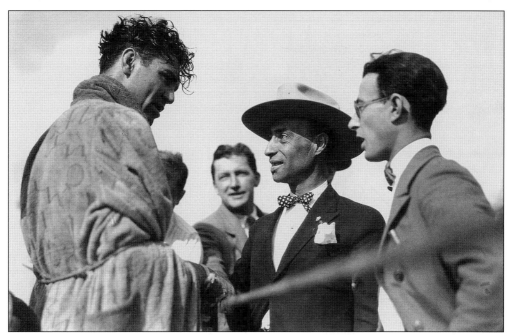

Fans catch a word with fighter Jack Dempsey (left) at a local outdoor exhibition boxing match on February 9, 1926. Dempsey was one of the most popular boxers in history and was known for thrilling knockout victories. This fight may have been staged behind the Club Morocco casino along the river in Temple Terrace.

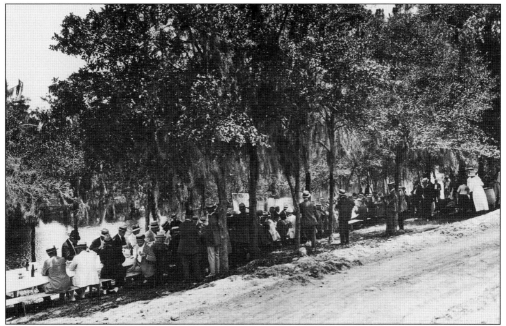

The Tampa Rotary Club enjoys a picnic on the riverfront at Temple Terrace on May 27, 1921. As a part of the sales and promotional efforts being made to sell homes, property, and citrus groves, Burks Hamner invited large groups of Tampa businessmen on inspection trips to view the property. (Photograph by Burgert Brothers; TTPL.)

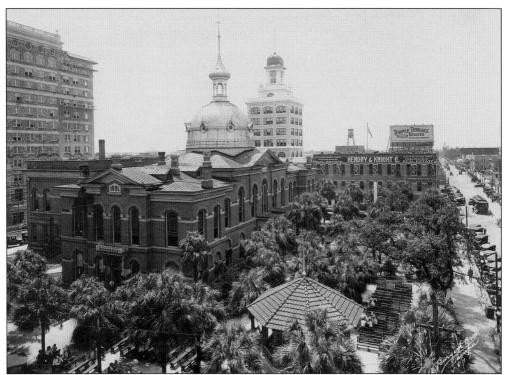

In this image of downtown Tampa dated August 5, 1920, a billboard can be seen atop a building promoting "Temple Terrace Estates, Florida's Masterpiece, Restricted Homesites." Offices for Temple Terraces, Inc., were located in the nearby Hillsboro Hotel, where developers D. Collins Gillett and Maud Fowler were based. This view is looking south on Franklin Street.

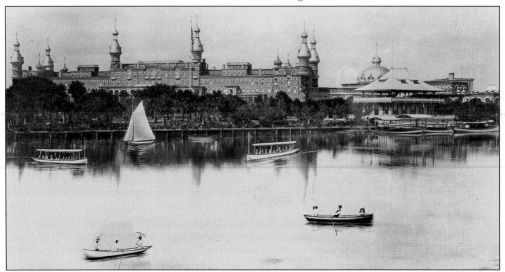

The Tampa Bay Hotel is a lavish Moorish Revival luxury resort hotel built by Henry B. Plant on the Hillsborough River in downtown Tampa. Seen here in March 1923, it served as headquarters and point of arrival for many Temple Terrace visitors, including Florida Open golfers and female Olympic champion swimmers completing in Temple Terrace events. The Temple Terrace private bus line began service in February 1923 and made four round-trips daily to the hotel.

Four

THE LARGEST CITRUS GROVE IN THE WORLD

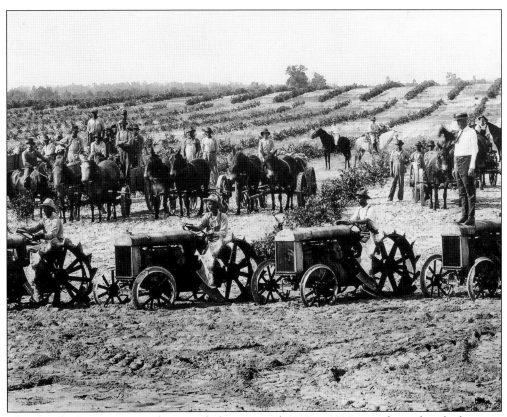

This detail of a panoramic photograph from around 1921 to 1922 provides a close look at just a few of the men and machines put to work in developing the Temple Terrace orange groves. Plowing was accomplished with tractors and disc plows, and 400,000 trees were to be planted on the first 4,000 acres of property.

Thought to have originated from budwood taken from a Jamaican seedling, the original temple orange mother tree was discovered in the grove of John and Mary Hakes in Winter Park, Florida. They consulted citrus grower William James Temple, who immediately recognized its value. The Hakes decided to protect the tree from possible theft of its budwood with a 10-foot-tall wire mesh fence. A sample of the fruit was sent to D. Collins Gillett, who was impressed enough to organize a pilgrimage to the tree. Prominent citrus growers, editors, and influential people were invited to join the expedition. Convening in Tampa, the group boarded a deluxe railroad coach on February 3, 1920. They were served luncheon en route and, upon arrival at the Winter Park train station, were met by a motor cavalcade and transported to the grove.

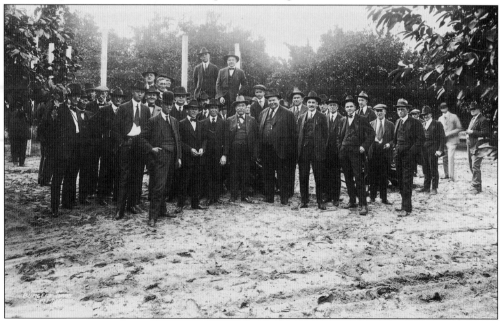

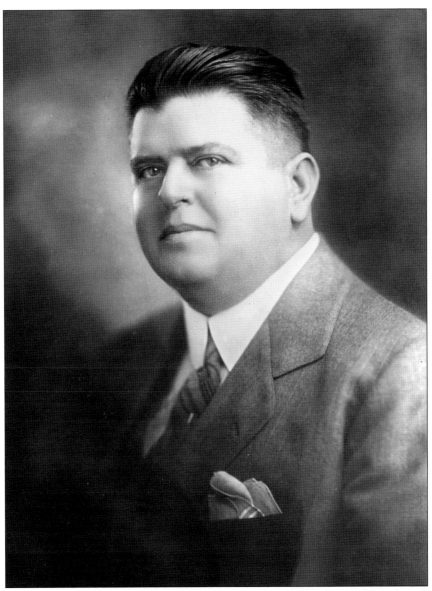

D. Collins Gillett, seen in this portrait dated June 16, 1926, was president and founder of Temple Terraces, Inc. He was also president of Buckeye Nurseries, the first and largest citrus nursery in the state; director of the Florida Citrus Exchange and the Exchange Supply Company; and an officer or board member of numerous organizations. A prominent figure in the citrus industry, Gillett also served on many notable delegations in Washington, D.C., New York City, and nationwide. He was quoted in a *Tampa Morning Tribune* article in 1921: "As Floridians generally know, I have been interested in citrus development since boyhood devoting most of my time to such work since coming out of college, and my father, Myron E. Gillett, was a pioneer producer and nurseryman before I was born. His interest in Florida's citrus … caused him to establish Buckeye Nurseries 41 years ago and to develop it into the largest citrus nursery in the world. His chief interest from now on lies in the careful development of the temple orange, which is undoubtedly the highest grade of citrus fruit yet evolved." Gillett became the first mayor of Temple Terrace, and his father, Myron, had been mayor of Tampa. (GRTTPS.)

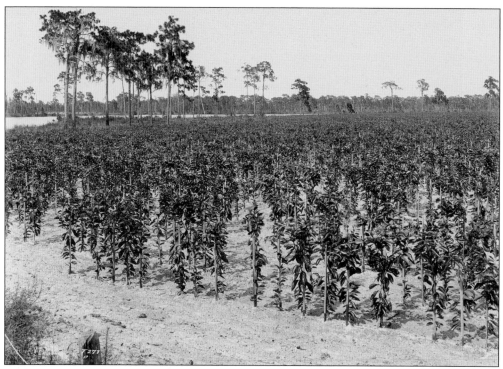

Buckeye Nurseries was founded by Myron E. Gillett. In December 1922, D. Collins Gillett succeeded his father as president and was also president and founder of Temple Terraces, Inc. The vast expanse of citrus trees shown here on August 21, 1920, is just a small part of the stock used to supply 5,000 acres of temple orange groves in Temple Terrace.

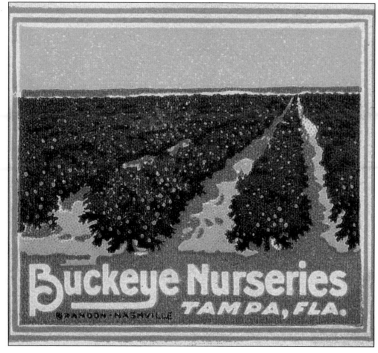

This Buckeye Nurseries mailing label features an illustration of the orange groves at Temple Terrace. The purity of the temple orange tree stock was fiercely protected, and purchasers were required to sign an ironclad agreement that they would not resell their new trees or permit budwood to be taken from them. A temple orange tree could not be labeled as such without possession of a contract by the grower. (GRTTPS.)

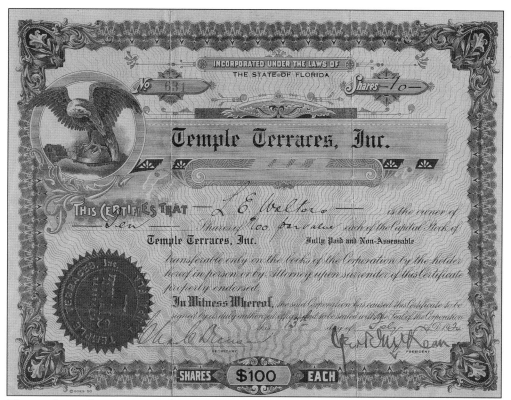

This stock certificate was issued to L. E. Walters on February 13, 1924, for 10 shares of Temple Terraces, Inc. To allow participation by those unable to buy acreage, stock was made available for purchase at $100 per share. Any purchase of a block of 10 or more shares included a country club membership and one building lot. Ten percent of the purchase price of stock shares was to go into a fund for the clubhouse, streets, bungalow sites, ornamental trees, and general public improvements. Another stock issue was released in January 1923. (GRTTPS.)

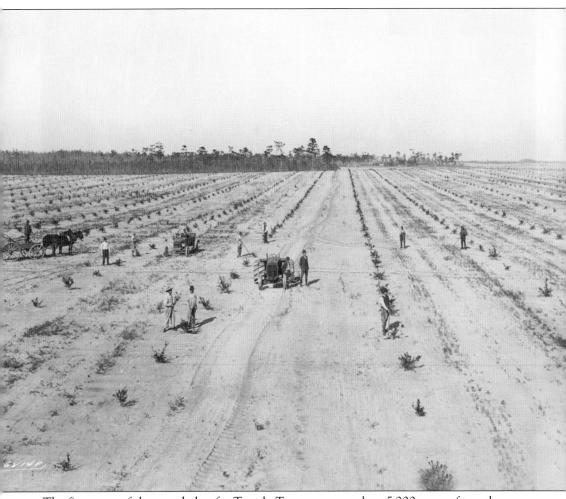

The first stage of the grand plan for Temple Terrace was to plant 5,000 acres of temple orange trees, making it the largest citrus grove in the world at the time. By February 1921, work had commenced, and what remained of the original longleaf pine forest after early turpentining was felled by clear-cutting. The panoramic image seen here of workers toiling in the sandy soil with mule-drawn wagons and early Fordson Model F tractors compellingly illustrates the grand scope

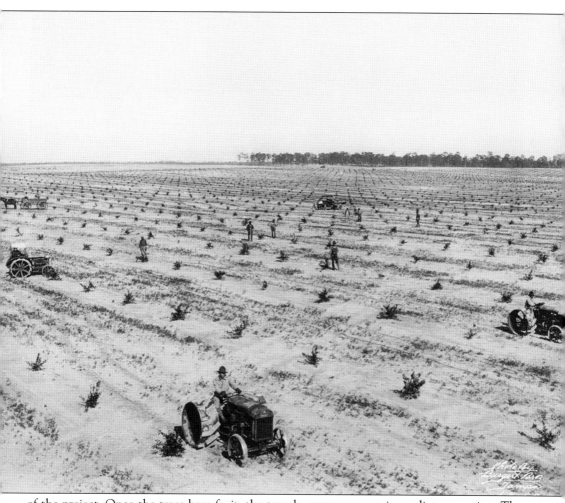

of the project. Once the trees bore fruit, the temple orange was an immediate sensation. The Atlantic Coast Line Railroad constructed a spur to Temple Terrace, located near today's 113th Avenue, to bring in building materials for the development and to haul the temple oranges to northern markets. Within a few years, the groves were expected to produce one million boxes of temple oranges annually.

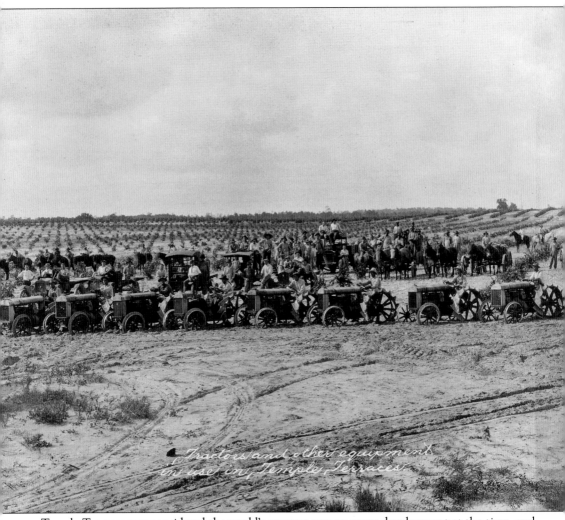

Tractors and other equipment in use in Temple Terraces

Temple Terraces was considered the world's greatest orange grove development at the time, and construction was documented by the Burgert Brothers, prominent Tampa commercial photographers. Specializing in panoramic photographs like these, the brothers used a special Cirkut camera, which could take a photograph either 8 or 10 inches high and from 2 to 5 feet long. When groups of people were involved, each person would line up in an arc or semicircle with everyone the same

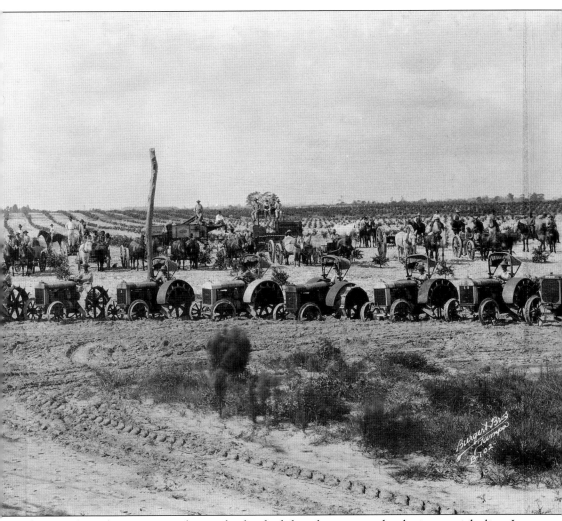

distance from the camera, so that in the finished shot they appeared to be in a straight line. In this photograph, grove workers, horses, mules, and equipment have been meticulously posed in front of row after row of temple orange trees that disappear on the far horizon. The sand road in the foreground is Druid Hills Road. (Photograph by Burgert Brothers; GRTTPS.)

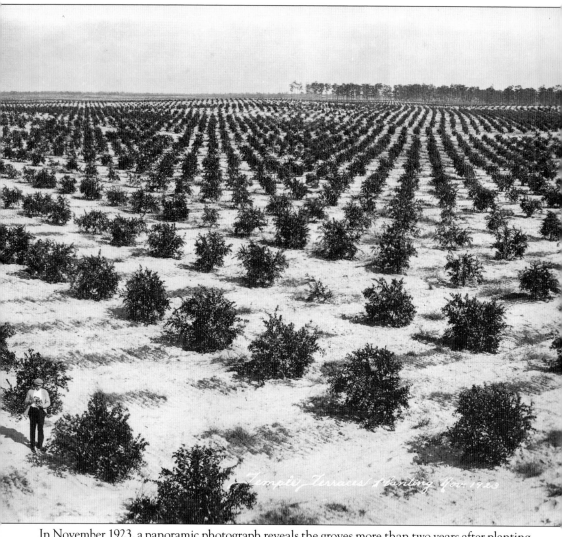

Temple Terraces Planting Nov 1923

In November 1923, a panoramic photograph reveals the groves more than two years after planting. A visitor can be seen at lower left with an armful of temple oranges freshly picked from the fruit-bearing trees. This view is from the northeast, from what is today Fortieth Street in the Temple

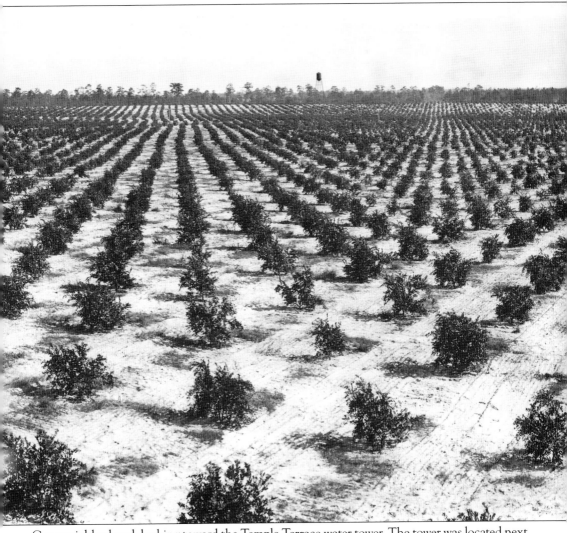

Crest neighborhood, looking toward the Temple Terrace water tower. The tower was located next to the administrative and sales office on Inverness Avenue. Buckeye Nurseries, the first and largest citrus nursery in the state of Florida, was the exclusive supplier of the stock.

Two young women, Miss Sneed (left) and Miss Davis, pose with bouquets of orange blossoms in a grove near Temple Terrace in the late 1920s. Driving along the roads throughout Central Florida in the spring and passing mile after mile of orange trees in full bloom, the sweet scent would have been overpowering.

Canadian tourists are shown picking orange blossoms from the two-year-old trees in the Temple Terrace groves on March 17, 1923. It is likely the visitors had never before seen oranges growing on trees.

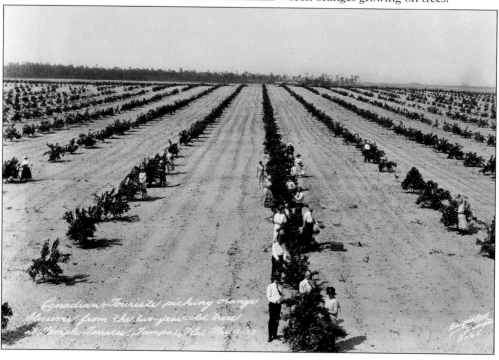

Canadian Tourists picking orange blossoms from the two-year-old trees at Temple Terrace, Tampa, Fla. Mch 17-23

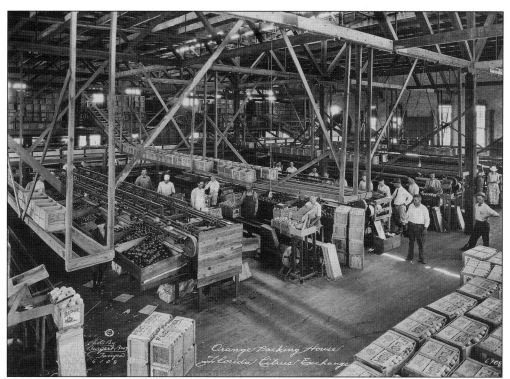

Florida Citrus Exchange, a cooperative association of citrus growers, was the second largest marketing organization in the country in 1924, handling nearly six million boxes of citrus grown by its associates. In this image of an exchange packinghouse from the 1920s, stacked crates of oranges are ready for shipping.

During the early years of the citrus industry, most groves were poorly managed. Few were sprayed to control pests, and almost none were irrigated. Buckeye Nurseries, under the leadership of D. Collins Gillett, was responsible for the planting and care of Temple Terrace's temple orange groves.

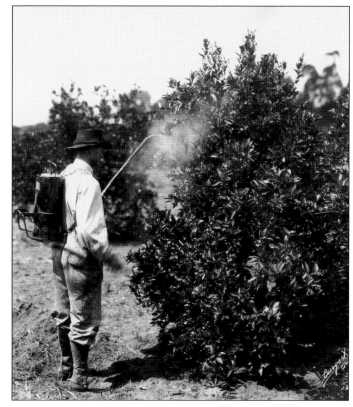

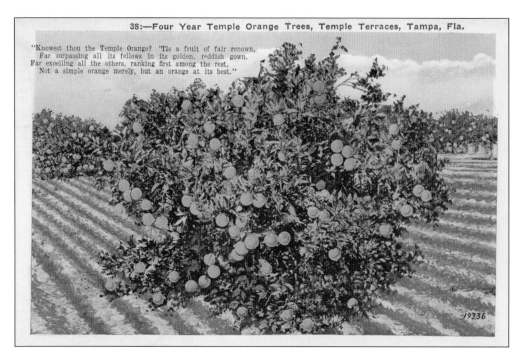

38:—Four Year Temple Orange Trees, Temple Terraces, Tampa, Fla.

"Knowest thou the Temple Orange? 'Tis a fruit of fair renown,
 Far surpassing all its fellows in its golden, reddish gown.
Far excelling all the others, ranking first among the rest,
 Not a simple orange merely, but an orange at its best."

These popular postcards from the 1920s feature colorized photographs of the Temple Terrace orange groves. Poetic verses printed on the images are excerpts from a poem said to have been written by one of the first purchasers of groves in the city, Clara A. March. The entire ode, "Where The Temple Orange Grows," was included in a *Tampa Morning Tribune* advertisement on December 25, 1921, promoting sales of the orange grove tracts. (Both, GRTTPS.)

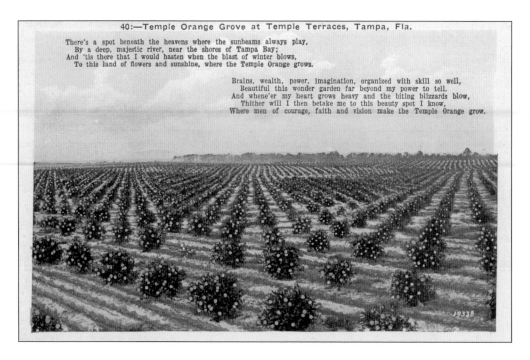

40:—Temple Orange Grove at Temple Terraces, Tampa, Fla.

There's a spot beneath the heavens where the sunbeams always play,
 By a deep, majestic river, near the shores of Tampa Bay;
And 'tis there that I would hasten when the blast of winter blows,
 To this land of flowers and sunshine, where the Temple Orange grows.

Brains, wealth, power, imagination, organized with skill so well,
 Beautiful this wonder garden far beyond my power to tell.
And whene'er my heart grows heavy and the biting blizzards blow,
 Thither will I then betake me to this beauty spot I know,
Where men of courage, faith and vision make the Temple Orange grow.

Five

A Planned Community

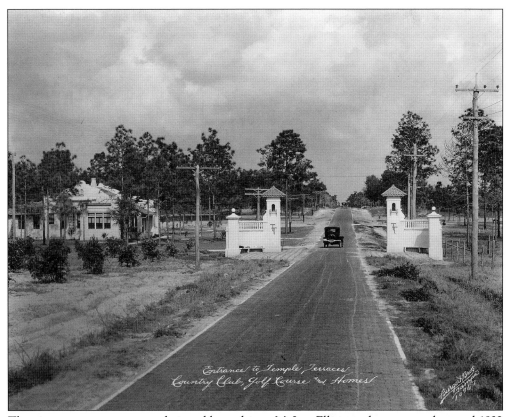

Entrance to Temple Terraces Country Club, Golf Course and Homes

The city entrance gates were designed by architect M. Leo Elliott and constructed around 1922 to 1923 just west of Ridgedale Road. In this photograph they appear to have just been completed. The groves can be seen on the left leading up to the Charles Dickson house, and a couple of Ford Model T cars head west on Temple Terrace Highway. The gates were demolished in the 1930s when Temple Terrace Highway was widened.

Architect M. Leo Elliott (1886–1967) was born in Woodstock, New York, and attended Cooper Union. Elliott came to Tampa in 1907 and right away won design competitions for several prominent structures, including Centro Asturiano de Tampa in Ybor City, the YMCA Building, and the original Tampa City Hall. In 1921, Elliott designed most of the public buildings in the new development of Temple Terrace, including the Temple Terrace Golf and Country Club clubhouse (considered one of his finest works), an addition to the Club Morocco casino, the administrative office of the city developers, the city gates, and the Chauffeurs Lodge and Garage. He also designed the first seven houses built for the developers and officers. Known to be a remarkably eclectic designer, Elliott produced a body of work that includes the redbrick and glazed terra-cotta Late Gothic Revival Sarasota High School, the architectural drawings and plans for the WPA–funded project of enlarging the Florida State Capitol in 1936 and 1937, and the design of several other Sarasota schools as well as the Sarasota County Courthouse. (LE.)

Architect Dwight James Baum (1886–1939) was born in Newville, New York, and graduated from Syracuse University in 1909. Before starting his own residential design firm around 1912, he worked for prominent architect Sanford White. A 1922 visit to Florida led to the commission to design Cà d'Zan, the 30-room mansion and estate of John and Mabel Ringling situated on Sarasota Bay. He also designed several significant civic buildings and a few other houses in Sarasota. In 1926, Baum designed 42 Mediterranean Revival–style residences of varying sizes in Temple Terrace, most of which still remain. This is thought to be the largest collection of his work in the Southeast. During the Great Depression, he became involved with historic preservation and later designed the Hendricks Chapel on the Syracuse University campus (with John Russell Pope) as well as the pedestal for the V. Renzo Baldi statue of Columbus in New York's Columbus Circle. Baum was distantly related to writer and designer L. Frank Baum, author of the Wizard of Oz books. (LOC, LC-G612-17165.)

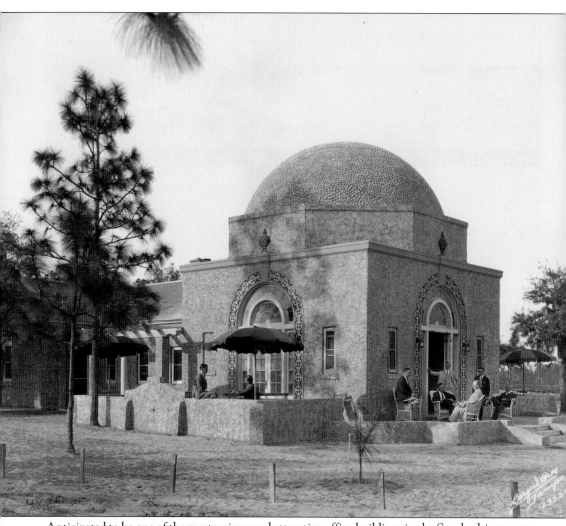

Anticipated to be one of the most unique and attractive office buildings in the South, this structure was one of the first buildings constructed in the community and housed the administrative offices for the developers of Temple Terrace. Seen here on February 25, 1925, it was designed by architect M. Leo Elliott in a predominantly Moorish style and featured a distinctive domed roof, with arched Palladian entry doors and transom windows on three sides with Moorish glazed tile surrounds. The wall finish was tinted stucco. By 1949, still struggling after the end of the Florida land boom and the Great Depression, the city lacked funding for needed renovations, and the building fell into disrepair. In 1948, the property was deeded to the Temple Terrace Community Church for $60. The church made significant improvements, and a plan is under way for restoring the entry doors to the original Elliott design. The Temple Terrace Preservation Society is assisting with this project. Located on Inverness Avenue on a point of land alongside Belle Terre Avenue, and adjacent to the golf course (hole 10), the building is a Temple Terrace landmark.

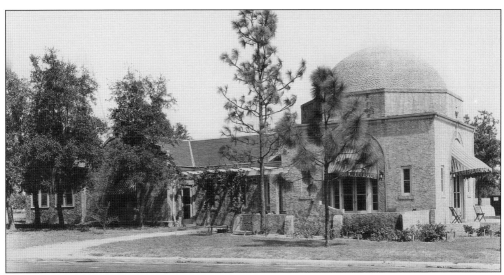

The administrative office building is seen here in July 1925. Used later as a real estate sales office for the development, this location likely worked with other sales branches throughout the country. Reportedly one of the largest operating in Florida, the Temple Terrace sales force was said to be working at capacity pace in March 1926, ringing up sales of $50,000 to $70,000 a day in Temple Terrace home sites and orange groves.

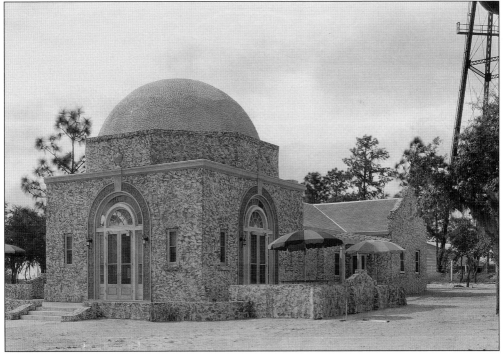

Another view on February 19, 1925, shows the remainder of the structure that extends behind the domed section, revealing a shaped parapet roofline at the rear. Common to Mission-style architecture, a similar parapet design is referenced in the clubhouse, the Greenskeeper's Cottage, and the Chauffeurs Lodge and Garage. The distinctive water tower, with the city's name emblazoned on the side, was removed in the 1940s.

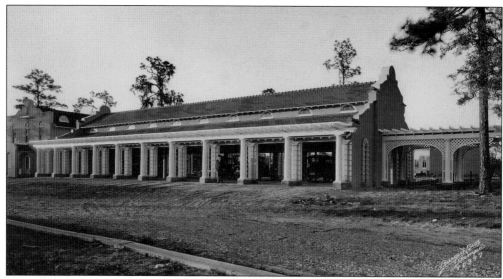

The architecturally significant Chauffeurs Garage was designed by architect M. Leo Elliott and built around 1922 to 1923 at 406 Belle Terre Avenue. It was planned to accommodate up to 50 limousines and automobiles for Temple Terrace Country Club clubhouse/hotel guests. The structure was acquired in 1944 (along with the adjacent Chauffeurs Lodge) by Florida Christian College (later Florida College) and demolished in 1958.

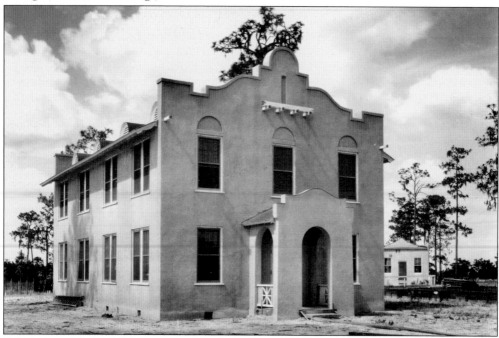

Adjacent to the Chauffeurs Garage, the Chauffeurs Lodge was also designed by Elliott and built around 1922 to 1923. The Mission-style building was acquired in 1944 by Florida Christian College (later known as Florida College) and used as a men's dorm until 1958. It then became the office and library of Florida College Academy, an elementary school. The building, seen here prior to the construction of the Chauffers Garage, was demolished in 2004. (Photograph by Burgert Brothers; FC.)

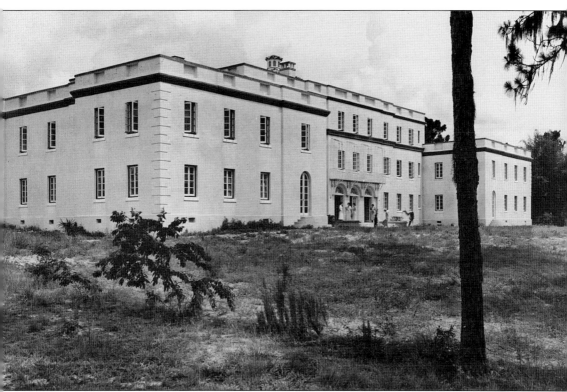

Terrace Apartments, a three-story building constructed in 1926 just south of and adjacent to the country club clubhouse, was designed by prominent New York City architect Lawrence Bottomley. The fashionable cooperative concept was modeled after the successful New York co-op apartment system, where occupants shared maintenance expenses. Its 35 rooms were furnished with modern, sumptuous fittings, with a Frigidaire cooling system, steam heat, and self-operating elevators. Construction was hollow tile with stucco finish. Its location was intended to allow residents easy access to enjoy the facilities and lifestyle afforded by the adjacent clubhouse and golf course. The structure was planned to be much more ornate than it appears in the photograph, but the Great Depression halted construction before it was complete. Later purchased by Florida College and used for student housing, the Terrace Apartments building was demolished in 2007. (Photograph by Burgert Brothers; FC.)

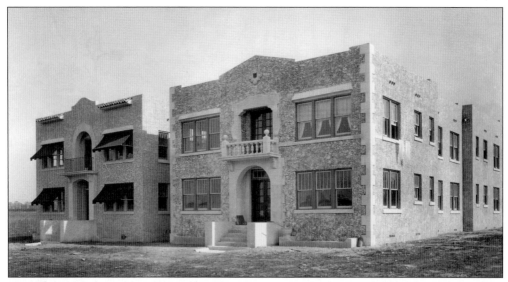

In 1926, four Mediterranean Revival luxury cooperative apartment buildings were constructed on Sunnyside Road (today the location of Doral Oaks Apartments). These buildings were later sold, around 1929 or 1930, and heavily insured by the new owners. A mysterious fire soon destroyed the buildings, but occupants had been warned to leave, and no one was hurt. The owners were eventually convicted of insurance fraud and served time in prison. (Photographs by Burgert Brothers; FC.)

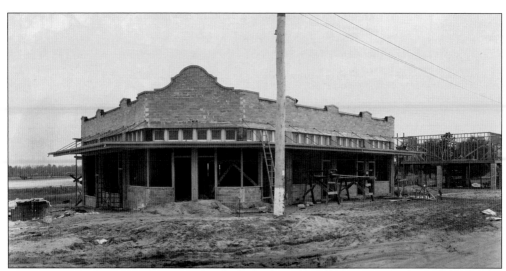

The United Markets building and the filling station beyond are shown under construction on February 18, 1926. The first two buildings of the planned Temple Terrace business district, these were the only ones completed before the Great Depression halted further construction. The United Markets building was later demolished, and the filling station exists today as Beacon Plaza. Temple orange groves can be seen on a rise in the distance.

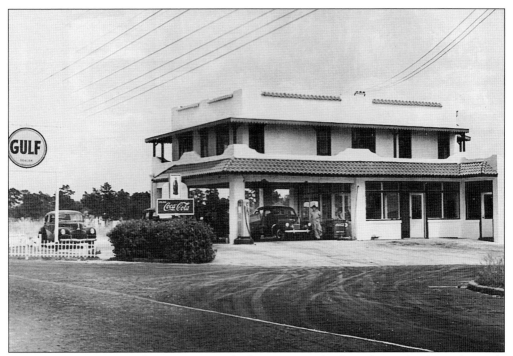

Seen here in 1949, this filling station was built in 1926 as the first phase of a planned Temple Terrace business district, near the intersection of Fifty-Sixth Street and Temple Terrace Highway. The Mediterranean Revival–style building, with a covered porch for customers to drive beneath, was later renovated into Beacon Plaza, a retail center that exists today. (JDR.)

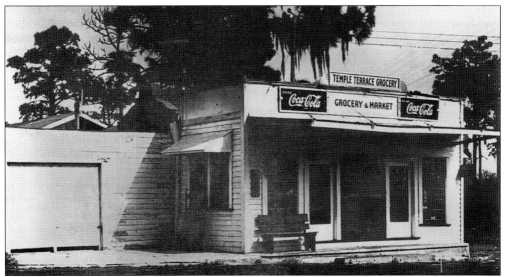

Temple Terrace Grocery and Market was built in the 1920s on the northeast corner of the intersection of North Glen Arven Avenue and Temple Terrace Highway. Later it became Bennett's Grocery, and Thomas W. Bennett and his family lived in the attached residence. The building also housed the city telephone switchboard and in 1961 became the U.S. Post Office branch for Temple Terrace. It was demolished in 1979. This photograph is from 1949. (JDR.)

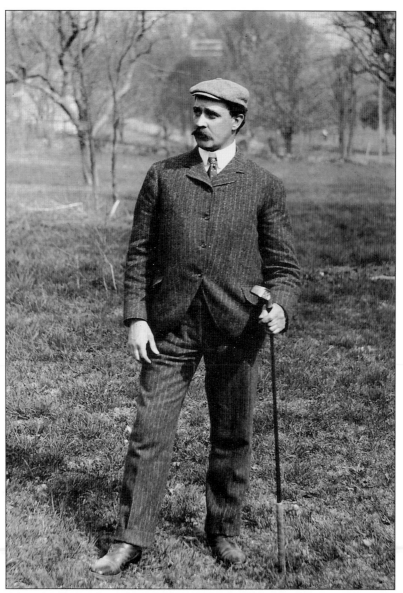

Tom Bendelow (1868–1936), architect of the Temple Terrace golf course, became known as the Johnny Appleseed of American Golf after immigrating to the United States in 1892 from Aberdeen, Scotland. He was hired by sporting goods manufacturer A. G. Spalding to promote the game of golf and designed a private six-hole course for the Pratt family of Standard Oil fame. In 1898, Bendelow was hired to redesign and manage the Van Cortlandt Park Golf Course in New York, the country's first 18-hole municipal course. Bendelow introduced various innovations, including the use of reserve play (tee) times, public player associations, public golf instruction, and training for caddies. He even developed his own line of golf clubs. In 1920, Bendelow joined American Park Builders Company in Chicago as chief golf course designer and focused on designing comprehensive city plans, subdivisions, country clubs, golf courses, and golf course communities. He teamed with landscape architect and civil engineer George F. Young to create the 1921 Temple Terrace master plan and is perhaps best known for course no. 3 at the Medinah Country Club. (Stuart Bendelow.)

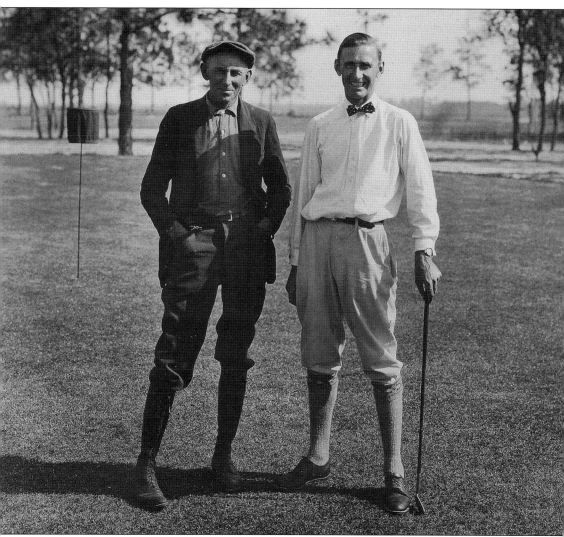

On the Temple Terrace golf course in 1925 are greenskeeper J. R. Bob Nelms (left) and course pro James "Long Jim" Barnes. Nelms later became the city's first night policeman, equipped with a bicycle and a watchman's clock. James Martin Barnes (1886–1966) was born in Lelant, Cornwall, England, and worked as a caddy and club maker's apprentice while growing up. He moved to the United States and became one of the most prolific tournament winners for the first few seasons of the PGA tour. Barnes won the PGA championship in 1916 and 1919, the U.S. Open in 1921, and the British Open in 1925 and was the resident professional at Temple Terrace Country Club from 1923 to 1926. He was nicknamed "Long Jim" because of his 6-foot, 4-inch height. Barnes was considered a keen student of the game of golf and authored several books on technique. Good friend and fellow golfer Fred McLeod wintered with Barnes in Temple Terrace in 1925–1926, and they both also worked with a young protégé, James Kelly Thomson, who hailed from the same area of Scotland as McLeod. Thomson was born into a golfing dynasty and later became one of the youngest and most popular players on the PGA tour, known for his booming tee shots. (Photograph by Burgert Brothers; GRTTPS.)

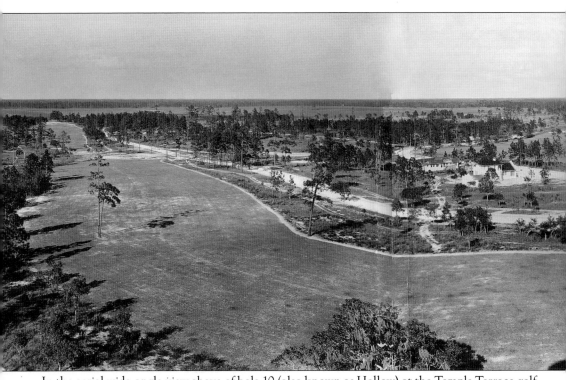

In the aerial wide-angle view above of hole 10 (also known as Hollow) at the Temple Terrace golf course, Bannockburn Avenue can be seen in the foreground, and the Hillsborough River can be glimpsed through the trees beyond. A Scottish tradition began in the early days and still exists today at Temple Terrace. Course designer Tom Bendelow was Scottish; Scottish names were

OPPOSITE: The enlargement of the clubhouse at right shows scaffolding in front while the building was still under construction. (Photograph by Burgert Brothers; GRTTPS.)

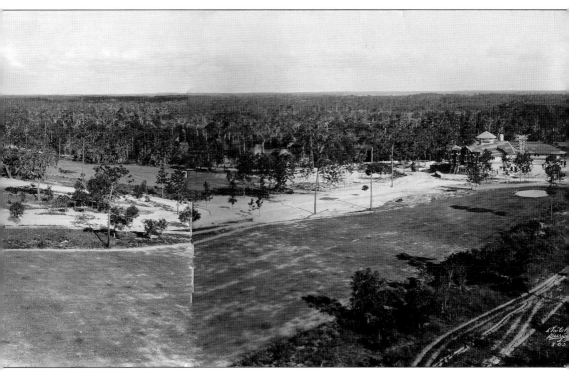

given to many streets in the community, and two of the first golf pros on the scene were Scots James Kelly Thomson and Fred McLeod. This photograph dates from around 1922. (Photograph by Burgert Brothers; GRTTPS.)

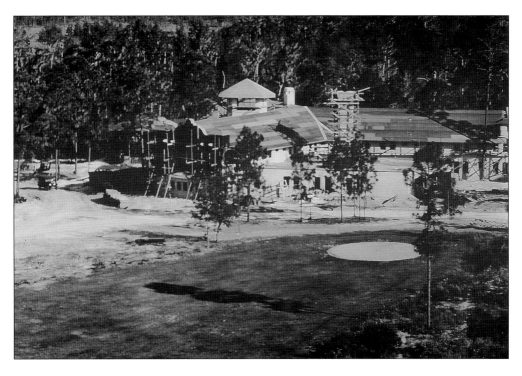

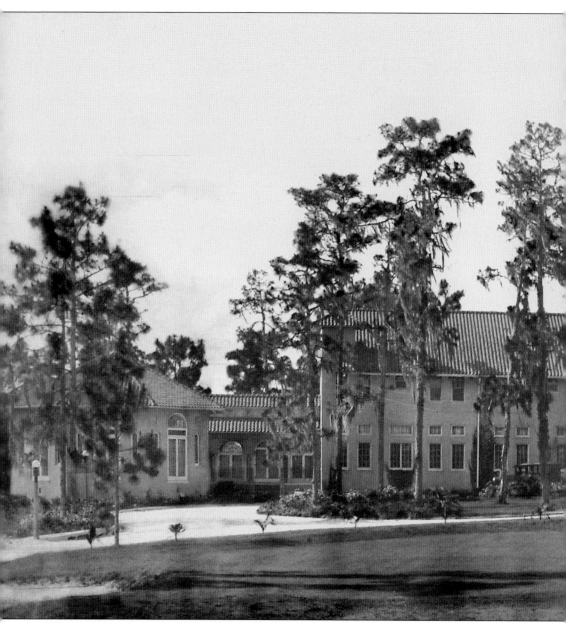

Still in existence today, the original Temple Terrace Country Club clubhouse was the centerpiece of the planned golf course community and was completed around 1922 to 1923. Designed by architect M. Leo Elliott in the Spanish Mission style, it was built of steel and concrete with tinted stucco finish and red clay roof tiles. An elegant entrance featured a stylish glass and wrought iron awning and marble steps. The clubhouse became a popular center for Tampa Bay society. A city founder,

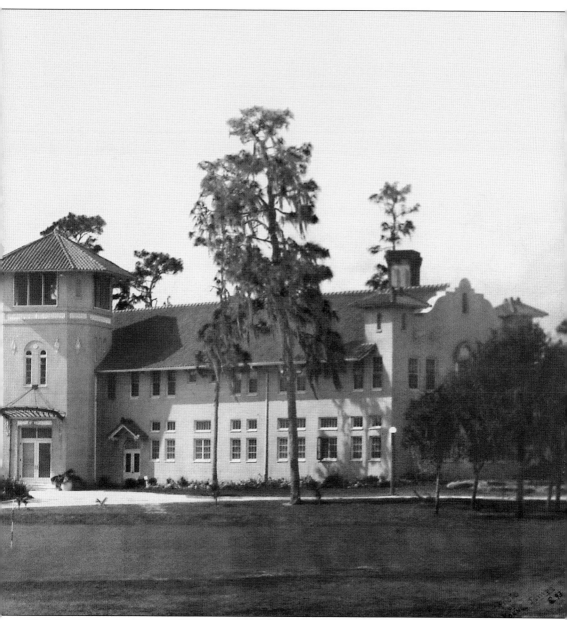

Cody Fowler, once wrote in a letter to a friend that it "was quite an elegant place . . . the scene of my social events and there were numerous parties at the nightclub. The clubhouse . . . was really a hotel, and a large number of guests were also grove and/or lot owners. In the winter, the hotel was largely filled with wealthy gentlemen from the North who enjoyed golf." Today the building is a women's dormitory for Florida College. (Photograph by Burgert Brothers; GRTTPS.)

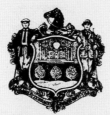

The Management of

Temple Terraces Country Club

cordially invites you to attend the

Washington Ball

Wednesday evening, February twenty-first

nineteen hundred and twenty-three

Eight thirty o'clock

This Washington Ball invitation was issued for the opening event of the first winter season of the Temple Terrace Country Club in 1923. Several hundred guests attended, including Maud Fowler and D. Collins Gillett. Among the invitees was Bertha Palmer's brother, Adrian Honoré. After dinner, dancing continued until past midnight in the open-air pavilion of the country club. (GRTTPS.)

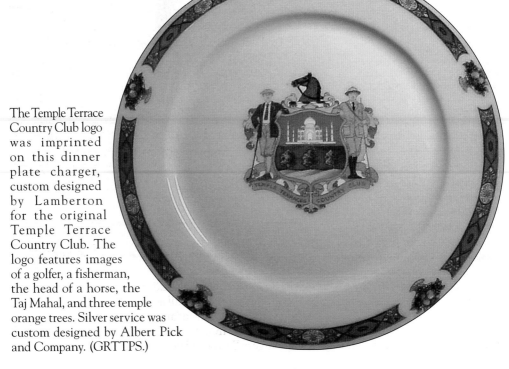

The Temple Terrace Country Club logo was imprinted on this dinner plate charger, custom designed by Lamberton for the original Temple Terrace Country Club. The logo features images of a golfer, a fisherman, the head of a horse, the Taj Mahal, and three temple orange trees. Silver service was custom designed by Albert Pick and Company. (GRTTPS.)

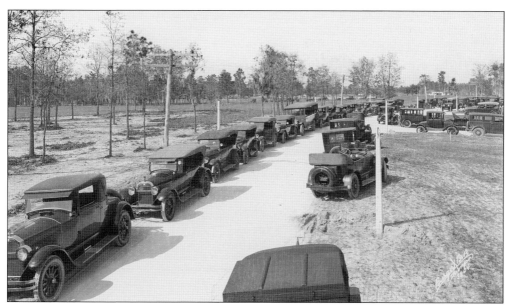

Parked cars line North Glen Arven Avenue in Temple Terrace leading to Club Morocco and the country club in what must have been a typical scene when any of the star-studded athletic and social events was taking place. The streetlights appear to have just been erected and stand awaiting completion, and trees on the golf course to the left have been freshly planted.

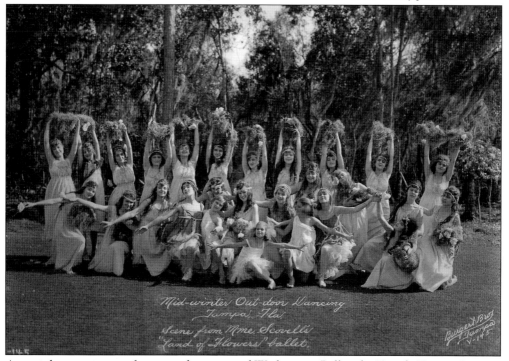

A special entertainment feature at the inaugural Washington Ball at the Temple Terrace Country Club was an interpretive dance presented by the pupils of Madame Lee Scovell on February 21, 1923. This photograph depicts the dancers in a scene from the ballet *Land of Flowers* on the golf course at Temple Terrace. (Photograph by Burgert Brothers; JW.)

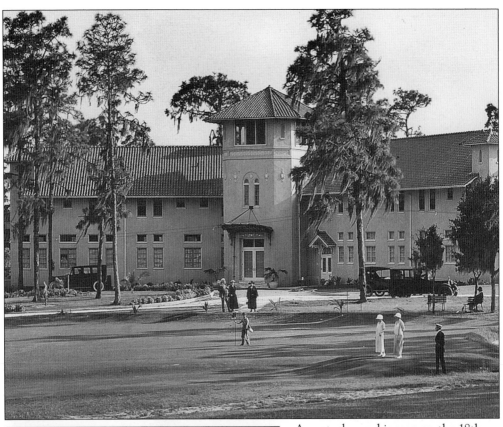

A genteel crowd is seen on the 18th green of the Temple Terrace golf course on April 6, 1924. Luxury automobiles line the circular drive of the elegantly appointed clubhouse. Just a few years prior, the area was mostly uncultivated woodland.

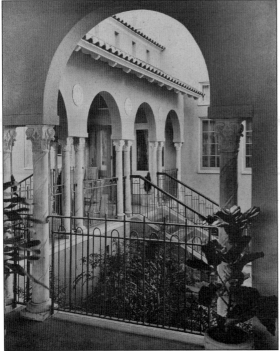

The interiors of the clubhouse were considered quite luxurious for the time. Paul Chalfin, nationally known decorator, artist, aesthete, and socialite was called in to work with Mrs. Vance Helm, wife of the Temple Terraces, Inc., director. Chalfin had worked on the Deering estate, Vizcaya, in Miami and had been an associate of the renowned decorator Elsie de Wolfe. This view is looking from the veranda towards the clubhouse. (Photograph by Burgert Brothers; GRTTPS.)

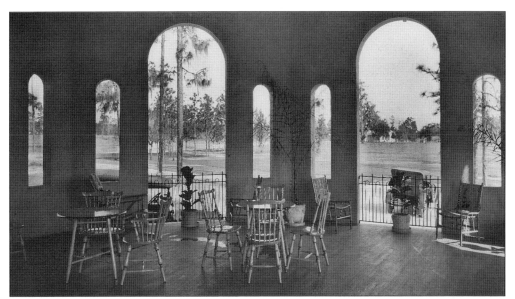

One of two six-sided pavilions, shown here before the arched openings were enclosed, was a romantic setting for nighttime dancing and was said to provide one of the most charming vistas in Temple Terrace, where it felt as if the river was almost at one's feet. Expansive views across the first hole of the golf course added to the effect. (Photograph by Burgert Brothers; GRTTPS.)

The long, narrow veranda of the clubhouse provided an elegant walkway to the dancing pavilions at each end. A series of grand and graceful arched openings along both sides, as shown in this later view, was enclosed with windows. The dark ceiling beams also appear to have been painted to match the French gray walls. The veranda was demolished by Florida College in the late 1990s. (Photograph by Burgert Brothers; FC.)

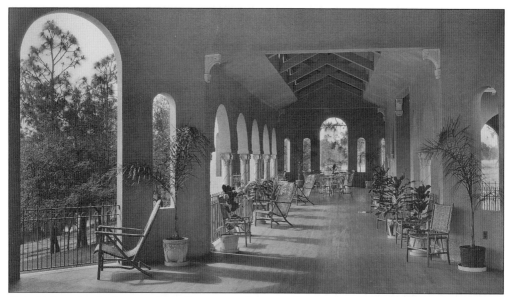

French doors in the lounge opened out onto the veranda, or upper terrace. Originally designed to be open-air, as seen in this photograph, its arched openings were later enclosed with windows, transforming the space into a sun parlor overlooking the Hillsborough River and the sweeping hills of Temple Terrace Estates.

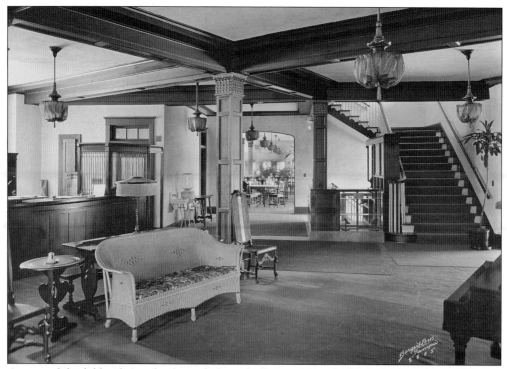

A view of the lobby shows the front desk to the left and the double entrance doors off to the right. Furnishings and curtains throughout were provided by Maas Brothers, and floor coverings were luxurious deep-pile velvet. (Photograph by Burgert Brothers; FC.)

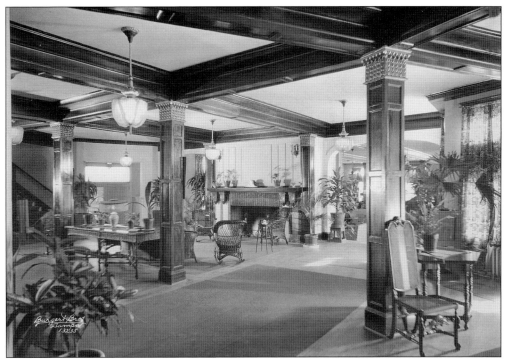

A formal atmosphere pervades the lobby with wood-beamed and coffered ceilings, columns, and a massive fireplace. Tan walls set off tan linen curtains with a Native American red-and-black pattern. The columns throughout the public spaces were topped with gilded, Corinthian-style caps, adding a touch of opulence. (Photograph by Burgert Brothers; FC.)

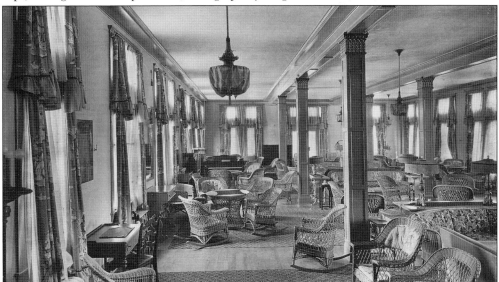

Three steps down from the lobby, the lounge walls and furniture were painted French gray. The rug was patterned, deep-pile gray velvet. Furnishings were upholstered with a peacock green and black patterned fabric with splashes of red, and windows were hung with gray silk curtains. Gray, black, and green print linen overdrapes were termed "irresistibly beautiful" by a visitor. (Photograph by Burgert Brothers; FC.)

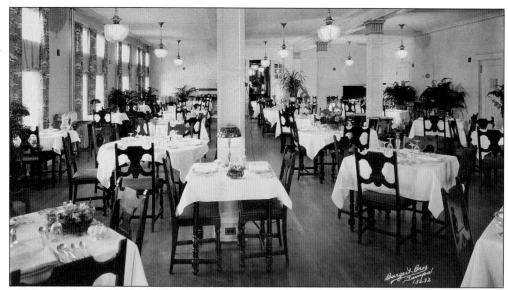

In homage to the temple orange, the dining room color scheme was citrus green, orange, and old ivory. The woodwork was painted ivory enamel, contrasting elegantly with the gold-capped columns. Orange silk shades covered the ceiling lights, old rose figured linen draped the windows, and chair fabrics were blue. Exotic floral- and bird-patterned draperies and fabrics were a constant theme throughout the country club interior. (Photograph by Burgert Brothers; FC.)

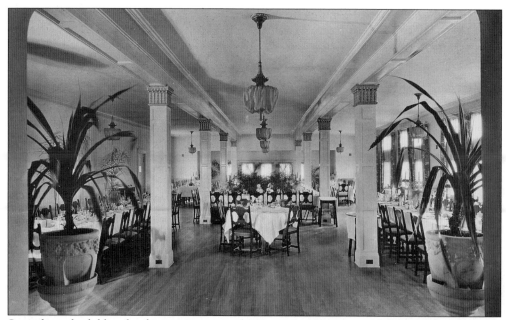

Steps from the lobby, the dining room seated 150 guests. Elegant appointments included fresh flowers on every table, custom-designed place settings and silverware, and palms and ferns in pottery containers. Tall windows filled the room with natural light. The clubhouse was designed with several wings, so that every room would have outside views. (Photograph by Burgert Brothers; GRTTPS.)

The plan of the clubhouse produced many surprising and charming nooks throughout the building. The ladies' writing room was tucked away on the second floor and was considered one of the most beautiful public spaces. The furniture was made by Tampa Wicker Furniture Company; the rug was black velvet, and a water lily-and-bird patterned fabric provided colorful accent. (Photograph by Burgert Brothers; GRTTPS.)

This is one of 36 private guest rooms, all designed with varying color schemes. Most were arranged as two-room suites with a bath between, and every room had a large closet and running water. The second floor was devoted to guest suites, card rooms, and lounging rooms. (Photograph by Burgert Brothers; GRTTPS.)

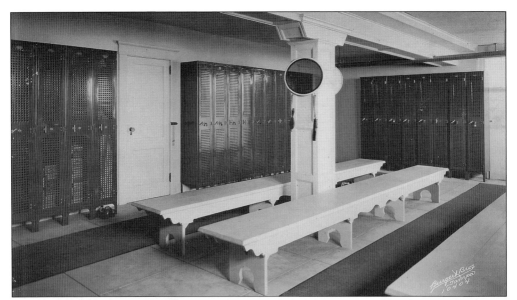

The golf locker room in the clubhouse basement included showers for golf and tennis players and also housed the headquarters for the golf course staff. It was considered quite a coup for Temple Terrace when Englishman "Long Jim" Barnes was hired as the resident professional in 1923. He remained in Temple Terrace until 1926. (Photograph by Burgert Brothers; GRTTPS.)

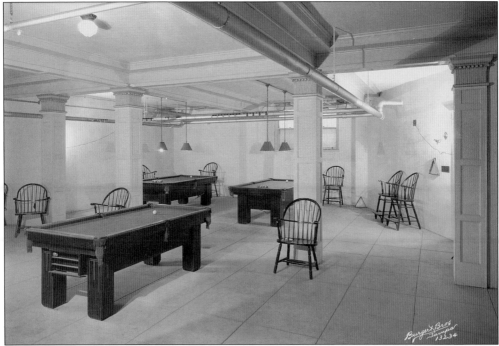

The poolroom, also in the basement, provided indoor recreation to augment the variety of outdoor sports and activities that were planned for Temple Terrace Estates. At various times, it was reported that plans were in the works for polo, complete with polo grounds; bridle paths and a riding academy; roque courts; shooting and archery ranges; bowling-on-the-green courts; and an aviation field with four airplanes available for the amusement of guests.

The Temple Terrace Country Club grounds, with 18-hole putting green, were landscaped in a cultivated yet naturalistic style befitting the wooded riverside location. The steep slope of the land, leading down to the Hillsborough River, gave the clubhouse a feeling of being perched on a cliff. This photograph was taken on September 23, 1926.

A view of the Temple Terrace Country Club clubhouse on July 29, 1925, shows the rear of the veranda and pavilion and the garden, with its unusual 18-hole putting green. This area may have been illuminated for evening events and activities. Landscape architect and engineer George T. Young designed the city plan of winding roads and likely collaborated with golf course architect Tom Bendelow.

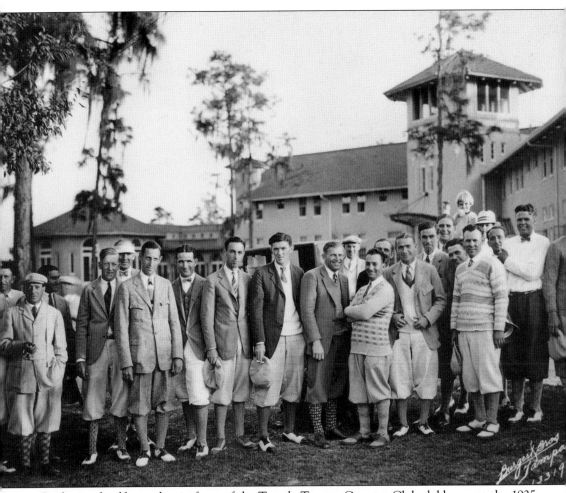

Professional golfers gather in front of the Temple Terrace Country Club clubhouse at the 1925 Florida Open golf tournament on February 24. The event attracted some of the best golfers in the country, including Walter Hagen and Gene Sarazen, competing for the largest purse ($5,000) ever offered in a Southern championship. The gallery was reported to be the largest ever to turn out for a Florida tournament. In this photograph are, from left to right, (first row) three unidentified, "Long Jim" Barnes, two unidentified, Roger Wethered (dark jacket, holding hat), Bill Mehlhorn, Gene Sarazen (arms crossed), tournament champion Leo Diegel, Johnny Farrell (slightly behind Diegel), unidentified, J. Wood Platt (striped sweater), and the remainder are unidentified. After the tournament, Barnes hosted the Knicker Ball, so-called to allow the golfers to wear their sporting attire to the event. The Brice Wilson Orchestra played in the ballroom after dinner.

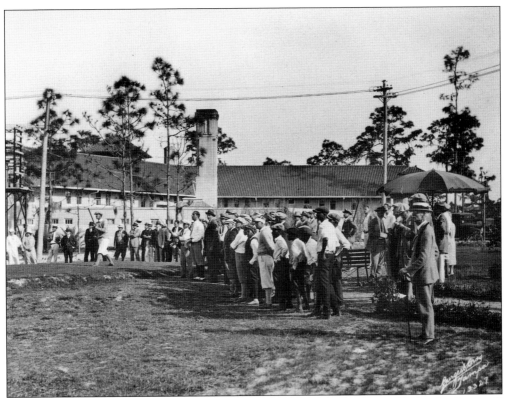

A crowd on hole 10 (Hollow) watches a professional golfer tee off at the 1925 Florida Open golf tournament on February 24, 1925. A total of 92 golfers competed in the tournament, on what had been deemed Florida's sportiest course. Spectators were encouraged to come by car and drive around the course with the players. Illuminated putting contests were to be held on the 18th green, with prizes for pros, amateurs, and ladies. The clubhouse can be seen in the background.

Tournament action takes place on hole 9 (Perfection) on February 24, 1925, with onlookers gathered along the green. The original Caddy House, which was demolished sometime before 1950, can be seen in the background on the right, and the lamppost-lined, winding road on the far left leads to the clubhouse. (Photograph by Burgert Brothers; TTPL.)

"Long Jim" Barnes (left) and Helen Wainwright pose in front of the original Caddy House on December 31, 1925. At the time of this photograph, Barnes was the Temple Terrace club professional, the reigning British Open champion, and a former U.S. Open champion. Wainwright was a former Olympic swimming star.

A crowd of golfers awaits play at the original Caddy House on February 25, 1925, during the Florida Open golf tournament. Most of the caddies who worked at Temple Terrace lived in Sulphur Springs. In 1931, the city purchased a bus for $150 to shuttle the caddies and domestic workers into Temple Terrace.

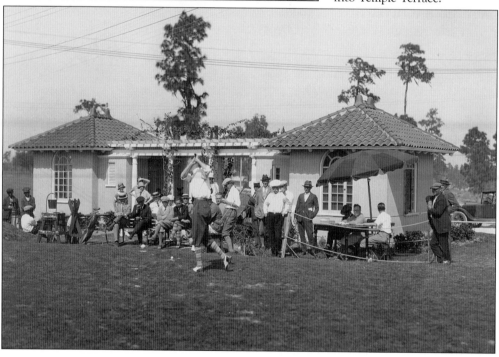

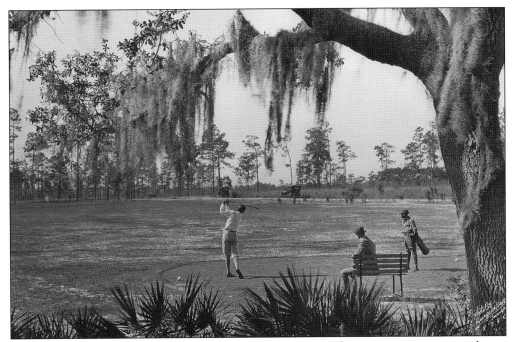

"Long Jim" Barnes tees off on hole 6 (River View) in 1925. The course was unique in design because none of the holes are parallel and all run alongside paved roads. The rustic setting of River View is enhanced with palmettos, seen in the foreground near a moss-draped sand live oak. (Photograph by Burgert Brothers; GRTTPS.)

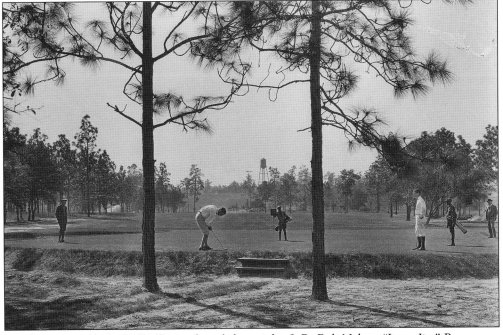

On the green of hole 11 (Hill) are, from left to right, J. R. Bob Nelms, "Long Jim" Barnes, an unidentified caddy, James Kelly Thomson, an unidentified caddy, and D. P. Davis. (Photograph by Burgert Brothers; GRTTPS.)

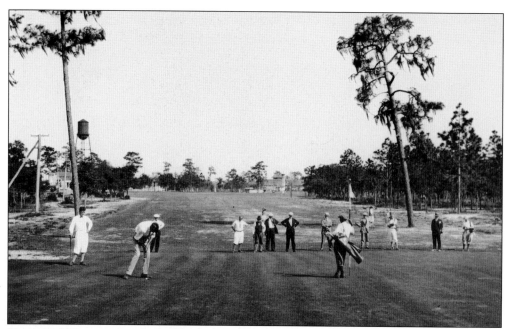

"Long Jim" Barnes puts the ball on hole 1 (Tower) at the 1925 Florida Open on February 24. The clubhouse was to be the setting for a banquet that evening hosted by Barnes for all the competitors, with more than 100 golfers (all old friends of Barnes and his partner Fred McLeod) expected to attend. (Photograph by Burgert Brothers; TTPL.)

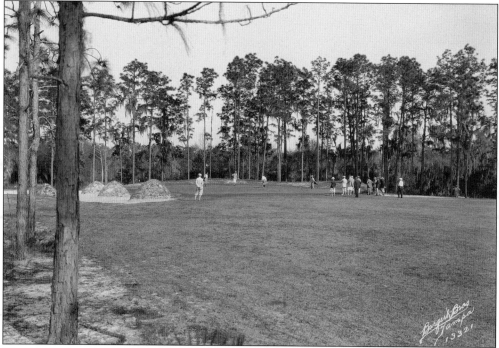

This 1925 view of hole 5 (Elbow) features a green nestled amongst longleaf pines. An early version of a sand trap, called a chocolate drop, can be seen on the left. The large cones of sand were difficult to maintain and are rarely seen on courses today.

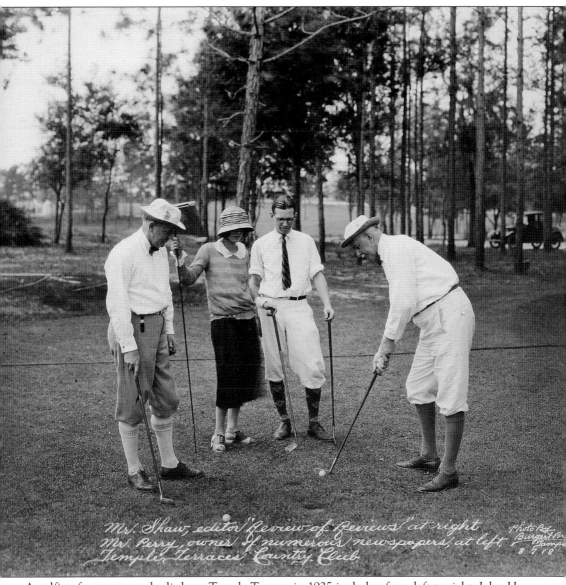

A golfing foursome on the links at Temple Terrace in 1925 includes, from left to right, John H. Perry Sr. (owner of numerous newspapers), unidentified woman, unidentified man, and Albert Shaw (prominent journalist, academic, and editor of the international magazine *Review of Reviews*) teeing off. The group may have been at the course strictly for a game of golf or possibly scouting out the new development for a press piece or taking stock of available property for sale. By February 1923, the first nine holes of the course had been completed and were ready for play, with fees of $1 a day, $5 a week, or $15 a month. Course architect Tom Bendelow, whose naturalist approach to golf course design was said to have been greatly influenced by Frederick Law Olmsted Sr. and Jr., strove to utilize the natural features of a site to maximum advantage. The course, as others at the time, was designed to be played with hickory clubs (no longer commonly used), which would make for a more challenging game. Bendelow, in Scottish tradition, gave names to each hole at Temple Terrace that were based on a physical feature of the hole. (Photograph by Burgert Brothers; JW.)

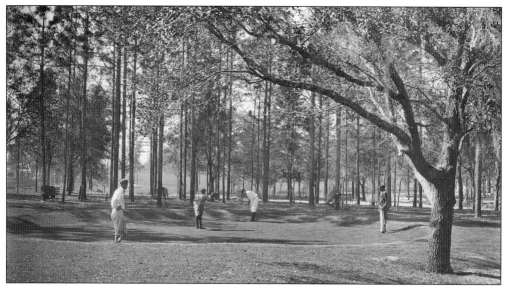

A 1925 view of the unique sunken green of hole 17 (Happy Hollow), set amidst a forest of longleaf pines, shows Sleepy Hollow Avenue just beyond. On the green, from left to right, are "Long Jim" Barnes, an unidentified caddy, James Kelly Thomson, and an unidentified caddy. (Photograph by Burgert Brothers; GRTTPS.)

In 1923, golfers and a crowd of onlookers surround the tee of hole 8 (Pond), which is located on a raised berm around a pond. The configuration of the pond obstacle has since gone through several redesigns. Course architect Tom Bendelow liked to work hole placements to take full advantage of unique features such as rocks, a scenic view, streams, or trees. (Photograph by Burgert Brothers; GRTTPS.)

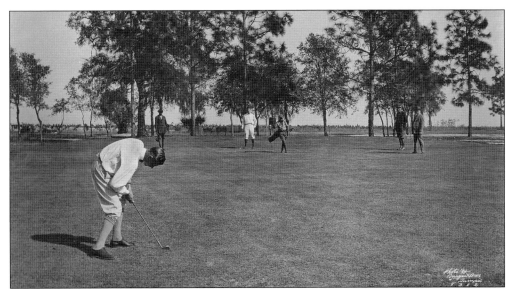

Seen here on hole 12 (Grove View) are, from left to right, "Long Jim" Barnes (golf pro), unidentified caddy, James Kelly Thomson (golf pro), unidentified caddy, J. R. Bob Nelms, and D. P. Davis. Druid Hills Road and the 5,000-acre temple orange grove are visible in the background. (Photograph by Burgert Brothers; JW.)

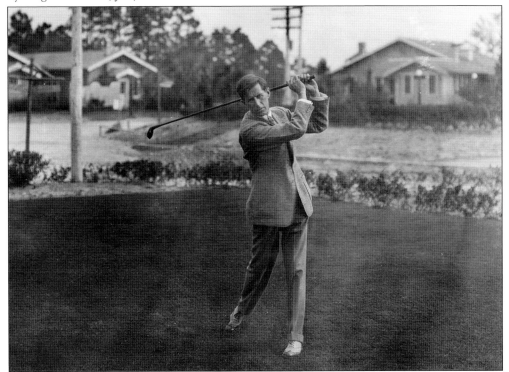

"Long Jim" Barnes tees off on hole 10 on December 30, 1925. In the background are two bungalows that were built by Bertha Palmer around 1910 to 1914 as part of her Riverhills hunting preserve and ranch. The clubhouse and surrounding property were purchased in 1944 by what is today known as Florida College, and the bungalows were demolished some years later.

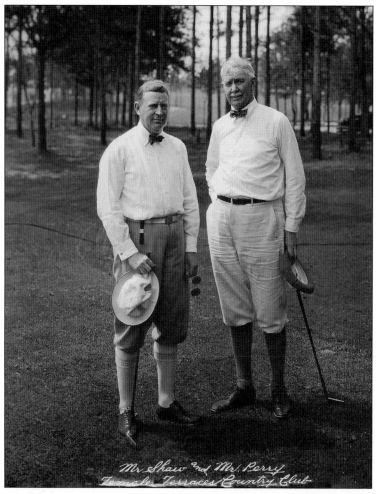

Two golfers pause on the course at Temple Terrace in 1925. John H. Perry Sr. (left) owned several newspapers, and Albert Shaw was a prominent journalist, academic, and editor of the international magazine *Review of Reviews*. Large stands of longleaf pine surround the green, and a car cruises past on the street beyond. (Photograph by Burgert Brothers; GRTTPS.)

This tiny Mediterranean Revival structure was built around 1922 or 1923 at the juncture of Riverhills Drive and North Glen Arven and Inverness Avenues. When the original Caddy House was converted into the Temple Terrace Country Club clubhouse, the caddies moved into this building. At one time it served as Temple Terrace police headquarters and later the Temple Terrace Public Library. The building was demolished in the 1970s. (JC.)

In this photograph, Dr. Billy Graham (right) is shown as a student at Florida Bible Institute in Temple Terrace. Graham, class president and a 1940 graduate, practiced his sermons on the banks of the Hillsborough River, preaching to the birds and wildlife, and made his commitment to evangelism on the 18th green of the golf course. (TC.)

The Greenskeeper's House, at left in the photograph below, is located at 201 Avondale Avenue. Today a residence, the structure was designed by M. Leo Elliott and built in 1922–1923. The Mission-style parapet design favored by the architect is a prominent feature of this building. The Chauffeurs Lodge can be seen in the background at right, behind the structure with the Buick touring car parked in front. (Photograph by Burgert Brothers; TTPL.)

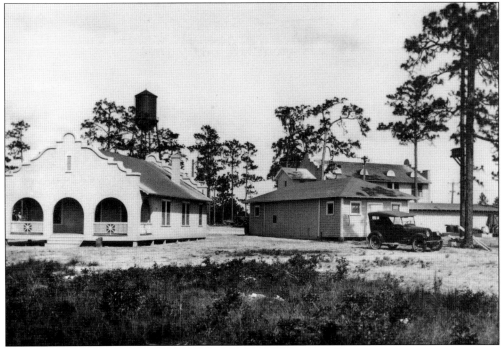

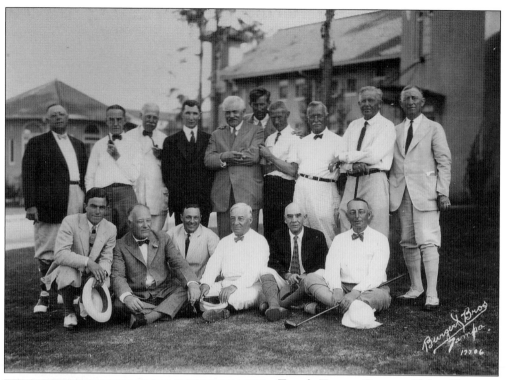

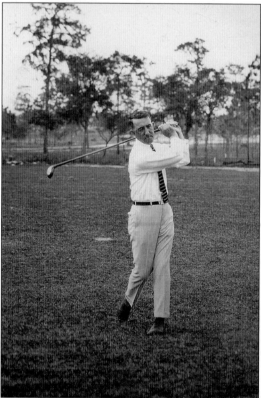

Temple Terrace Country Club golf pro "Long Jim" Barnes (second row, sixth from left) poses with a group of unidentified golfers (likely his students) in front of the original clubhouse in this c. 1925 photograph. In 1940, Barnes was honored as one of 12 golfers to be inducted into the PGA's inaugural Hall of Fame. (Photograph by Burgert Brothers; GRTTPS.)

Golfer Fred McLeod demonstrates his swing at Temple Terrace in 1925. McLeod was a close friend of "Long Jim" Barnes and won the 1908 U.S. Open as well as numerous other titles. McLeod and Barnes, as runner-up and winner, respectively, of the 1921 U.S. Open, were invited to the White House to have lunch with Pres. Warren G. Harding. McLeod wintered at Temple Terrace in 1925–1926. (Photograph by Burgert Brothers; GRTTPS.)

In town for the 1925 National AAU Women's Swimming Championship at the Club Morocco swimming pool, competitor Helen Wainwright picked up a tennis racket for a little fun on February 10. Even in her swimsuit and barefoot, she displayed perfect form on the clay surface of the courts at the Temple Terrace Country Club.

A doubles match takes place in February 1926 on one of the eight rolled-clay tennis courts that were completed at the Temple Terrace Country Club in December 1922. The courts were available for club members, and many tournaments were also held on the site, including Tampa Tennis Club championship second-round and semifinal matches in 1926. (Photograph by Burgert Brothers; TTPL.)

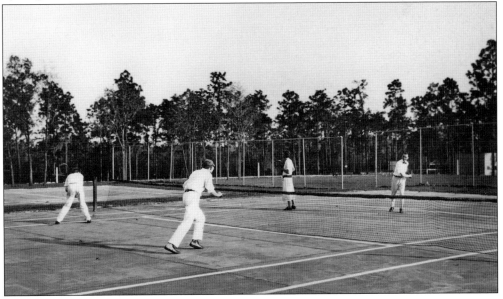

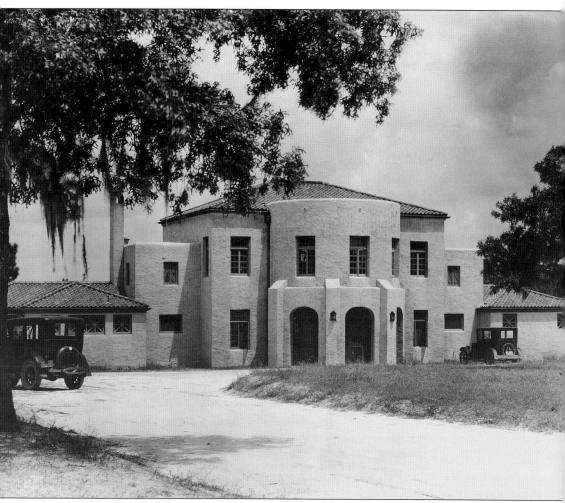

A palatial Turkish bathhouse with a ceramic tile and cement swimming pool was designed by Tampa architect Franklin O. Adams and completed by July 1924. Located near the Temple Terrace Country Club clubhouse, the natatorium was considered by some to be the most beautiful and artistic of its kind in the South, with an exotic curved and arched front facade of tinted stucco. Inside, the main room was tiled and open, with a wading pool for children, a large fireplace, and an electric fountain that, when illuminated at night, was visible from both the street and the swimming pool. Circular stairs at each side led to an upstairs dining room, dance floor, and a stage for concerts—in effect, a cabaret with a balcony overlooking the swimming pool and the Hillsborough River beyond. A new facade was later created (in 1926 by Tampa architect M. Leo Elliott) when a large ballroom and stage were added to the front of the building.

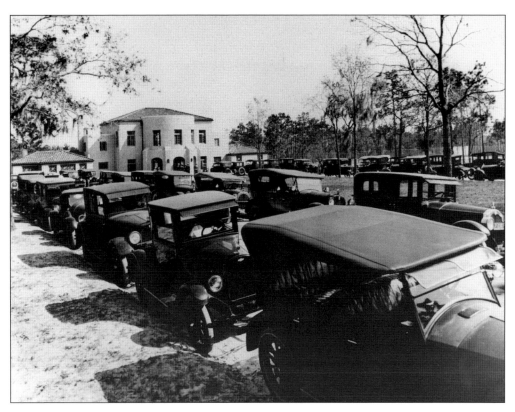

Admission to the casino and swimming pool was strictly by card. Crowds of Tampa residents and visitors from other parts of the country arrived by Temple Terrance Estates buses and automobiles every afternoon and evening, and the pool and the dining room on the second floor of the casino were open every night until midnight. Many would drive out in the early evening from Tampa, enjoy a swim in the pool, and then have dinner. Broadway entertainment with a nightly revue at 11:00 p.m. (except Sundays) included talent brought in from New York City and Europe. Club Morocco was said to be the most luxurious nightclub on the west coast of Florida in 1925; and in the gambling casino, formal attire was de rigueur, champagne was the drink of choice, and squab and pheasant were on the menu. Celebrities and star athletes were frequent guests.

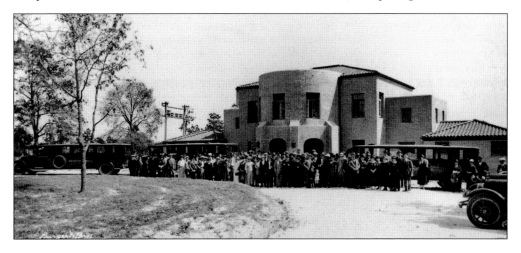

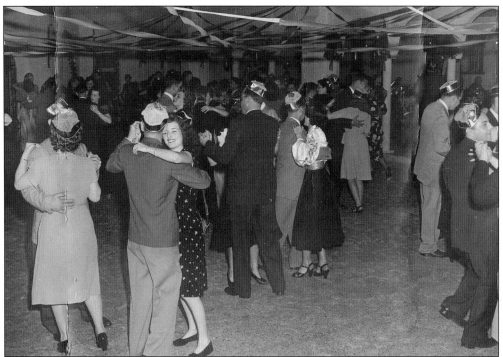

The interior of Club Morocco in the 1920s was decorated with elaborate tiling in the foyer, heavy cypress beams with Moorish designs, and a ceiling draped with bright silk. A mummy case said to be imported from Egypt was placed in a prominent spot. A guest might have rubbed shoulders with Al Jolson, Connie Bennett, or Babe Ruth in the casino or cabaret or cheered along with thousands of fans at an exhibition match of famed boxer Jack Dempsey on the riverfront. By the time these undated photographs were taken inside Club Morocco (probably in the 1940s), much of the original fanciful decor and frenetic excitement of the boom years had subsided. (Both, JC.)

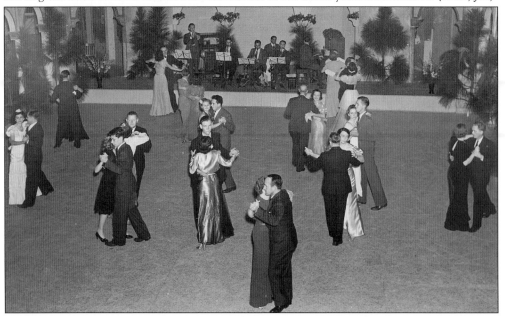

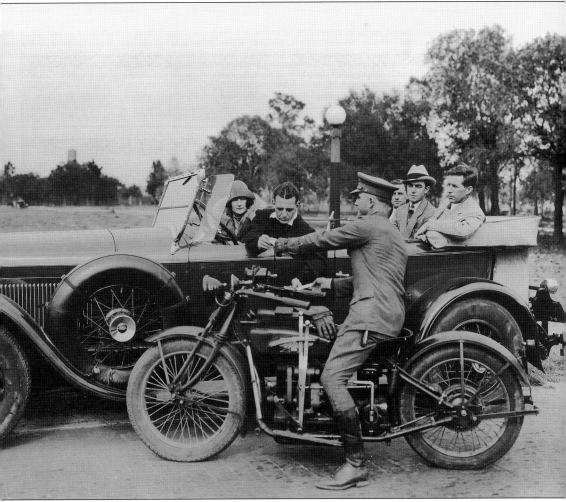

Football celebrity Red Grange, driving his 12-cylinder Duesenberg, is stopped for speeding by a police officer in Temple Terrace in 1926—and caught on camera at the same time. Grange is paying for his ticket in cash. In the front passenger seat is Helen Wainwright (Olympic champion swimmer), and in back are, from left to right, Joe Mickler (director of Public Relations, Greater Tampa Chamber of Commerce), Johnny Farrell (golf pro in Tampa and at Quaker Ridge Golf Club in Mamaroneck, New York), and "Long Jim" Barnes. A photographer who had been taking pictures of internationally known athletic stars at the Temple Terrace Country Club had just packed up his camera and started back to town when he happened upon the incident. Reportedly, the group was on the way to pick some fruit in the temple orange groves. The golf course can be seen in the background, along with one of the original street lamps and, in the far distance, the water tower. (GRTTPS.)

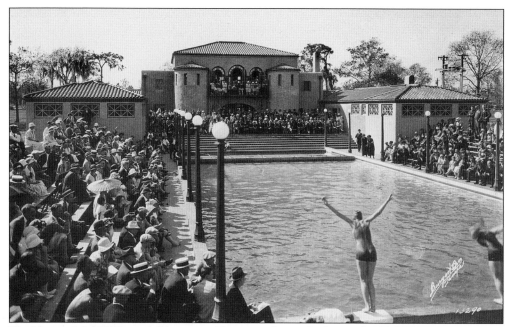

The National AAU Women's Swimming Championship took place at the Club Morocco swimming pool on the weekend of Saturday, February 21, 1925. Temporary grandstands had been erected around the pool to seat 2,000 for the sensational event, and spectators lined the balcony and steps of Club Morocco. There were capacity crowds for the entire meet.

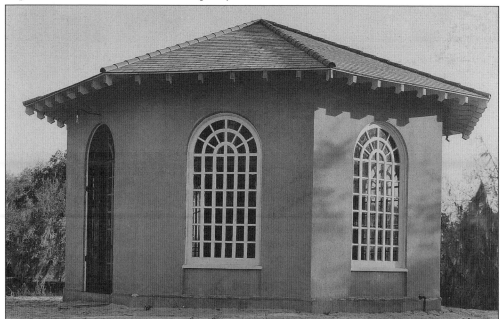

The Spring House, designed by architect M. Leo Elliott, was constructed in 1921 on North Riverhills Drive around a natural spring, which provided water for the swimming pool as well as the community. The water was cold and clear, and fish could be seen far below. Long after the structure was demolished, the spring remained a popular swimming hole until the late 1960s, when construction of the Tampa Bypass Canal breached the aquifer, and the spring's flow stopped.

In 1924, the swimming pool provided a natural and tranquil setting for these unidentified visitors to take respite from the summer heat, in the off-season between the more exciting athletic exhibitions that were frequently held to promote the sale of homesites and orange groves. (GRTTPS.)

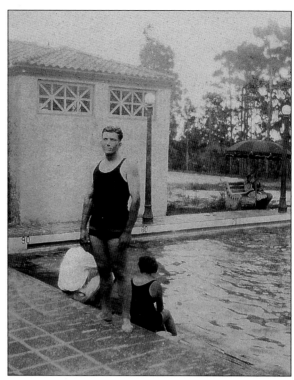

Seen in February 1925, the two building wings along either side of the pool and patio housed changing rooms for swimmers. On one side were locker rooms for men, and on the other, dressing booths for women. Visible at far right is one of the original cottages from Bertha Palmer's hunting preserve.

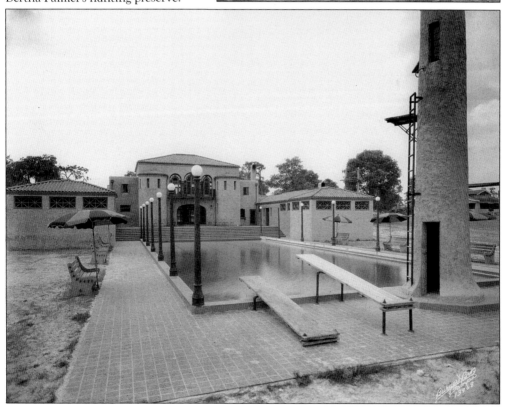

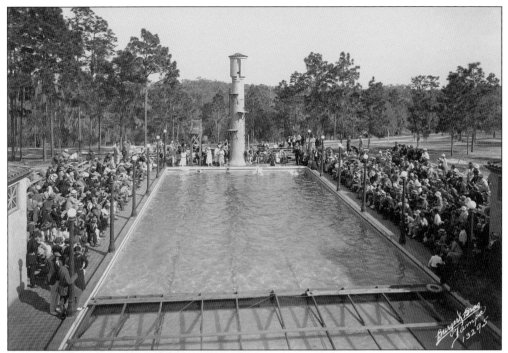

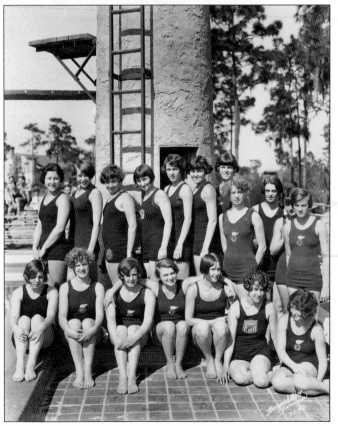

On a perfect day in February 1925, spectators watch the finish of a race at the National AAU Women's Swimming Championship in Temple Terrace. An expansive rooftop view of the pool shows off its natural setting amidst the rustic countryside of towering pines and the Hillsborough River.

Gertrude Ederle (first row, third from left) and Helen Wainwright (second row, second from right) join their (unidentified) competitors poolside on February 21, 1925. A dinner dance that was one of the social events of the season was held that weekend for the swim meet participants at the Temple Terrace Country Club clubhouse. (Photograph by Burgert Brothers; FC.)

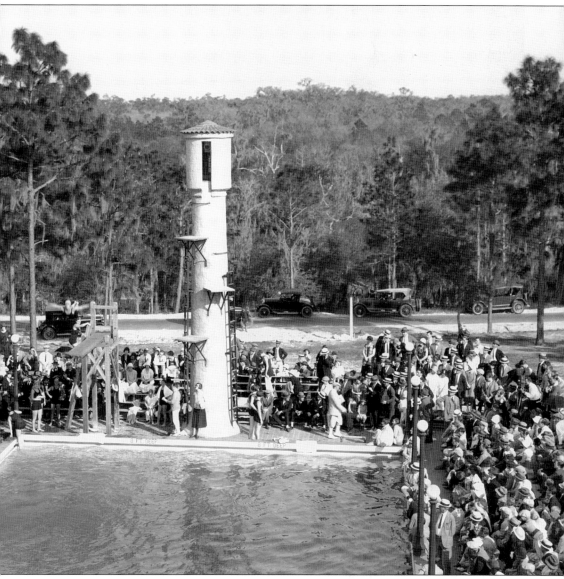

In this crowd scene at the swimming and diving competition on February 21, 1925, several swimmers are posing for a photograph next to the diving tower while platform diving continues at far left. Farther to the right, a man wearing a straw boater can be seen holding a camera, and at far right, a man stands behind a movie camera. (The Burgert Brothers photographers used their Devri movie camera to make commercial shorts for theaters.) Noted participants in the meet included Helen Wainwright, Gertrude Ederle, Aileen Riggin, Helen Meany, Agnes Geraghty, Carin Nillson, Ethel Lackie, Gretchen Allen, Harriet Prevost, Kent McCord, Eleanor Gerratti, Frances Cowells Sehroth, Martha Norelius, Ethel McCarry, Margaret Ravior, Virginia Whiteneck, and Marjorie Prevost. Beyond the pool, cars are parked along Riverhills Drive.

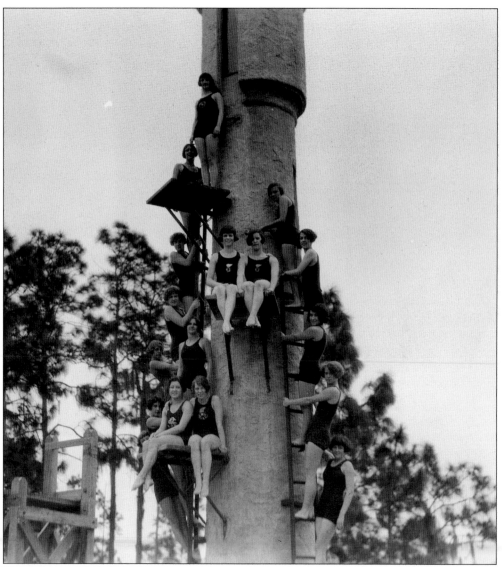

The February 21, 1925, swimming and diving competition was considered an event of national interest and referred to as a two-day aquatic carnival by the local *Tampa Morning Tribune*. The price of admission was $1 plus a 10¢ government tax. The diving tower had platforms at 10-foot, 15-foot, and 20-foot heights and two diving boards, or springboards. After the crowds had dissipated, swimmers perched on the various levels and steps of the tower for this photograph. During their stay in Tampa, the women were entertained in their free time by D. P. Davis, chairman of the Tampa Board of Trade Sports Committee, who took them out on his fleet of speedboats around Davis Islands and to a yacht club regatta. In 1926, the championship returned to this venue because the facility was considered superior to other locations under consideration.

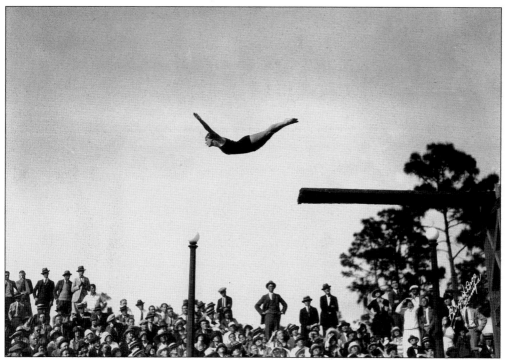

Two competitors appear to take flight, executing swan dives in the featured event, the National Fancy Diving Competition, on February 22, 1925. Helen Meany (below) won the high springboard diving contest, and Helen Wainwright took second place. The following year, when the top amateur swimmers in the country returned for the AAU championship on February 21, 1926, Helen Wainwright performed swimming and diving exhibitions. Wainwright completed an 11-mile swim around Davis Island the following month in four hours and 50 minutes, in preparation for an attempted swim across the English Channel. D. P. Davis, millionaire sportsman and developer, offered her $2,500 for the Channel crossing, but it was Gertrude Ederle who became the first woman to swim the English Channel in 1926.

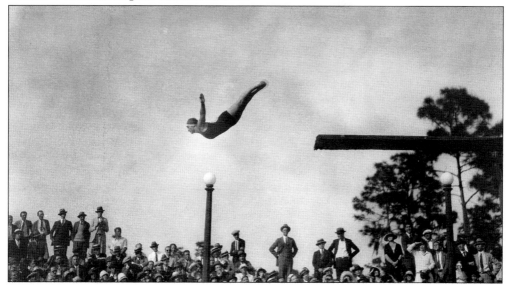

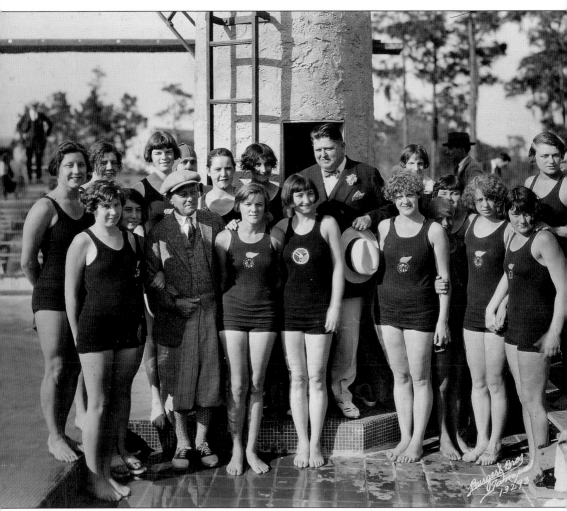

On February 22, 1926, the National AAU Women's Swimming Championship was again held at the Club Morocco swimming pool. More than 18 swimmers and divers competed, and several records were set. Shown standing by the diving tower are, from left to right, (first row) unidentified, Helen Meany, D. P. Davis, four unidentified, and Helen Wainwright; (second row) four unidentified, Gertrude Ederle, unidentified, D. Collins Gillett, and the remainder are unidentified. Among the participants, Helen Wainwright and Agnes Geraghty competed in the 1920 and 1924 Summer Olympics; Gertrude Ederle was the first woman to cross the English Channel; Helen Meany competed in the 1920, 1924, and 1928 Summer Olympics; Ethel Lackie won two gold medals in the 1924 Summer Olympics; and Eleanor Gerratti and Martha Norelius both won gold medals in the 1928 and 1932 Summer Olympics. (Photograph by Burgert Brothers; GRTTPS.)

Helen Meany (right) and an unidentified competitor take a break between heats at the Club Morocco swimming pool on February 22, 1926. Meany won 17 national championship diving medals from 1920 through 1928, including the gold in women's three-meter springboard diving at the 1928 Olympic Games in Amsterdam, and was named to the International Swimming Hall of Fame in 1971. (Photograph by Burgert Brothers; GRTTPS.)

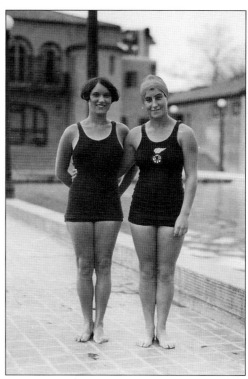

D. P. Davis watches Olympic champion swimmer Helen Wainwright sign a contract for a sports promotion on October 7, 1925. As chairman of the Tampa Board of Trade Sports Committee, Davis was involved in bringing national celebrity sports figures to the area for exhibitions promoting Temple Terrace as well as Forest Hills and Davis Islands. Davis was a large investor in Temple Terrace property and also developed Davis Islands.

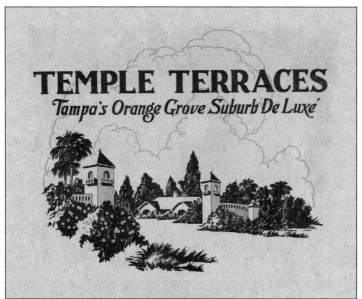

This early sales brochure dates from 1923. The cover of "Temple Terraces: Tampa's Orange Grove Suburb De Luxe" features a line drawing of the entrance gates, lush landscaping with orange trees, and a home beyond. Inside text refers to "the wild beauty of the scenery on the river" and how "the homes among the pines present a picture which hints of foreign lands—of Spain or Italy." (GRTTPS.)

Al Severson, after a successful fishing trip on the Hillsborough River in April 1926, loads up his touring car with oars, a boat motor on the running boards, and a string of bass for dinner. Severson was a longtime employee of Burgert Brothers photography and became sole owner of the company in the 1950s.

Upon arrival in Temple Terrace about 1921, noted Temple Terrace golf course architect Tom Bendelow said of the section of the Hillsborough River that runs alongside the city: "A stretch of water over 4 miles in length is at the disposal of the aquatic expert, and canoeing and boating can be indulged in to the heart's content . . . the finny tribe is in abundance, for one has only to stand on the banks and watch schools of bream and trout go by while pike and bass are aplenty, waiting for the lure that will tempt." In a photograph dated November 16, 1923, Al Severson and an unidentified boy enjoy a day of fishing for large bass. (Quote from the *Tampa Morning Tribune*, February 11, 1923.)

Fishing from the banks of the Hillsborough River near Temple Terrace, where black bass were plentiful in the early 1920s, a fisherman might have encountered such typical wildlife as white-tailed deer, river otters, alligators, bobcats, Florida panthers, black bears, and feral hogs. The upper Hillsborough River, north of Temple Terrace, is today recognized worldwide as a significant wildlife refuge that is home to many species that cannot be found in any other place. Birds that make their home in the area today include limpkins, wood storks, roseate spoonbills, pileated woodpeckers, white ibis, blue herons, Louisiana herons, several types of egrets, hawks, turkeys, and osprey. (Photographs by Burgert Brothers; JW.)

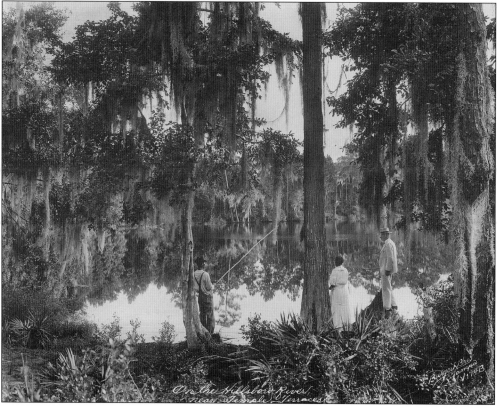

The tranquility of these 1920s scenes on the Hillsborough River at Temple Terrace are much like what would be encountered today, but perhaps in sharp contrast to life 14,000 years ago, when Ice Age migrations brought mastodons, woolly mammoths, giant sloths, tapirs, and saber-toothed cats to the area. Fossilized bones of these ancient creatures have been discovered by divers in the river near Temple Terrace. Geological data suggests that the waterway is 27,000 years old. It flows 54 miles, from its headwaters in the Green Swamp area of Pasco and Polk Counties through Temple Terrace and into downtown Tampa, where it empties into Tampa Bay. Over the years, dams have been created in the river for diversion of water and flood control. (Photographs by Burgert Brothers; GRTTPS.)

Built on the banks of the Hillsborough River around 1924, the Bat Tower was based on plans by Dr. Charles Campbell, an early pioneer of bat studies and a subsequent Nobel Peace Prize nominee. Campbell called the towers Hygiostatic Bat Roosts, and his intent was to create structures to attract bats in order to control the mosquito population. Out of an original 14 towers worldwide, there are three still standing today—one in the Florida Keys and two in Texas. Plans are currently underway to rebuild the Temple Terrace structure (which was burned by arsonists in 1979) as the focal point of the new 150-acre Riverfront Park. For the first phase of the project, a Bat Tower viewing pavilion was designed and constructed by University of South Florida architecture students in 2008. (GRTTPS.)

Six

A New Beginning

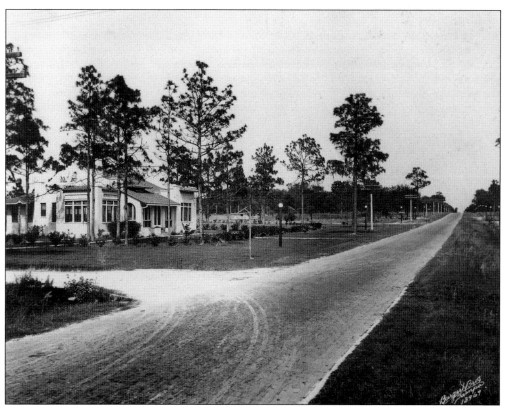

In this early 1920s image, the original lampposts can be seen on either side of Temple Terrace Highway at Ridgedale Road. Installed in 1922–1923, the lamps led from the entrance gates to the clubhouse and along the main streets of the community. In the early 1950s, when they were replaced with modern lighting, the original lampposts were offered free for the taking to any resident and can still be seen around city streets today. The Charles Dickson house is on the left.

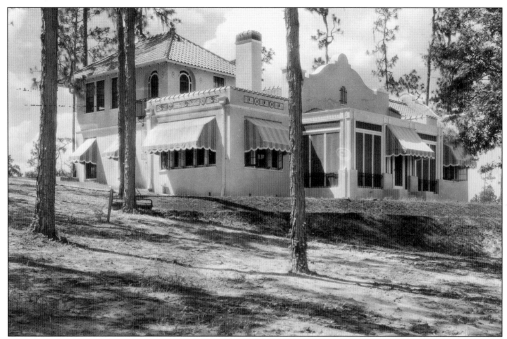

One of the largest and most palatial in Temple Terrace, the D. Collins Gillett House at 914 North Riverhills Drive was built in 1922–1923 and designed by architect M. Leo Elliott. Gillett was president of Temple Terraces, Inc., and the first mayor of the city. Situated on a bluff overlooking the Hillsborough River, the Gillett mansion also had expansive views of the golf course and the country club from one of the highest spots in the community. The shaped parapets, decorative tile banding, arched windows, and wrought iron details combined Mission and Spanish designs. Elliott deemed the structure an architectural triumph, but it was demolished in the 1980s and replaced with two new residences. The street scene photograph below dates from February 25, 1925. The terraced yard seen in the above image inspired the city's name. (Below, TTPL)

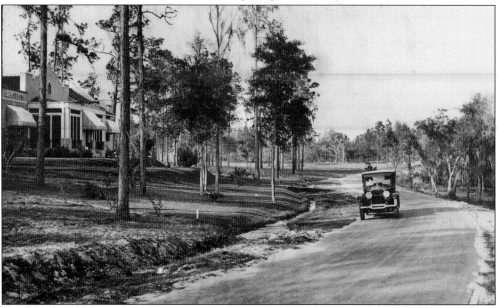

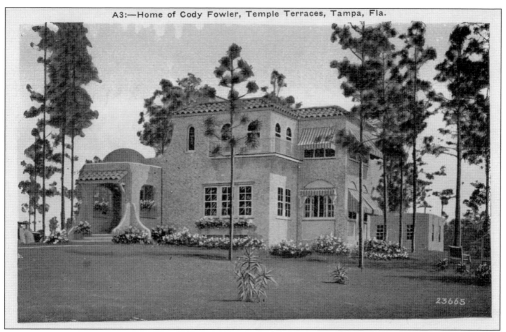

A3:—Home of Cody Fowler, Temple Terraces, Tampa, Fla.

The Cody Fowler House at 313 Sleepy Hollow Avenue is said to be the most photographed home in Temple Terrace. It was originally built in 1922–1923 for Maud Fowler, who sold the residence to her son, Cody, in 1926. A domed roof (also seen in other work by architect M. Leo Elliott) and entry porch were removed in the 1970s; the entry was relocated, and a loggia and large detached guest quarters were added. Built on about five lots with a healthy grove of longleaf pines, the home has expansive views of the golf course and river. The above image is a colorized postcard from the 1920s. (Photographs by Burgert Brothers; above GRTTPS; below FC.)

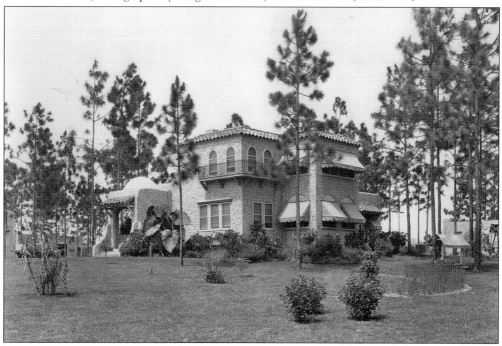

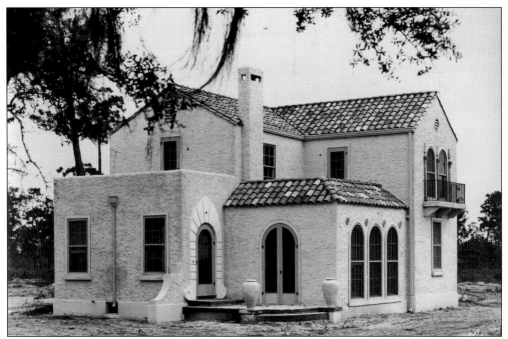

Designed by architect W. A. Schumacher and built by Nichols and Coyle in 1925, this Mediterranean Revival home at 304 Midlothian Avenue has eight rooms, servants' quarters, garage, solarium, and tiled mosaic floors. Located on the gentle slope of a hillside, it cost about $13,000 when new. Landscaping was provided by the Temple Terrace gardeners. Owner Warren M. Dilsaver was Temple Terrace city judge from 1926 to 1930. (Photograph by Burgert Brothers; TTPL.)

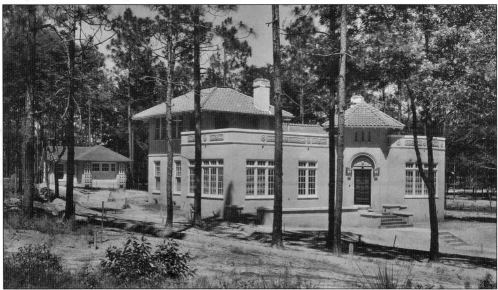

The L. B. Krumick House at 312 North Glen Arven Avenue was built in 1922 to 1923 and designed by architect M. Leo Elliott. Situated on several well-forested lots, it is the only 1920s residence in Temple Terrace with an entry tower. To the left of the entry tower is a solarium, and there is a rooftop terrace over the single-story section. It was deemed eligible for the National Register of Historic Places in 1988. (GRTTPS.)

Seen above on August 3, 1925, the Charles M. Hart House at 306 North Glen Arven Avenue was one of M. Leo Elliott's most imaginative. The screened porch features twisted Solomonic columns, and a bedroom suite on the second story has a domed roof and opens onto a rooftop terrace. One of the few houses in Temple Terrace with a basement, the structure recalls both the Mediterranean Revival style and the pueblo architecture of the Southwest. Some 25 years later (below, on May 5, 1950), few modifications of the original design are apparent. An addition was later made at the rear, but the house retains its distinctive appearance.

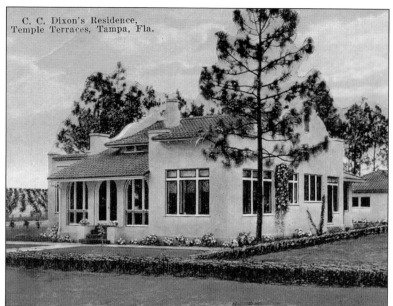

C. C. Dixon's Residence,
Temple Terraces, Tampa, Fla.

The photograph of Charles Dickson's residence was one of eight images of the community that were made into colorized postcards in the 1920s. Designed by M. Leo Elliott and constructed in 1922 to 1923, the Mediterranean Revival structure was one of the first of seven large estates built. (Photograph by Burgert Brothers; GRTTPS.)

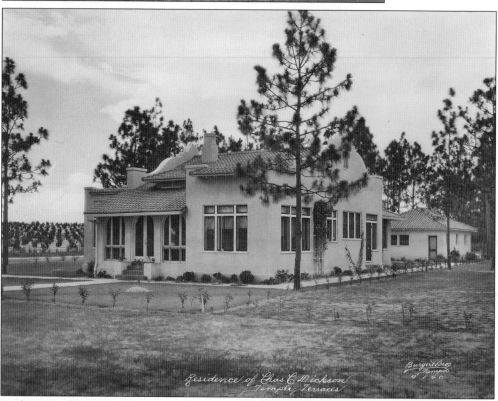

Residence of Chas C Dickson
Temple Terraces

In this May 23, 1923, photograph of the Charles Dickson House at 306 East Bullard Parkway, the temple orange groves can be seen in the distance on the left. The groves were planted up to Ridgedale Road at Temple Terrace Parkway next to the community entrance gates and extended west almost to Sulphur Springs and Thirtieth Street. Dickson was the secretary and treasurer of Temple Terraces, Inc., in 1923. (Photograph by Burgert Brothers; GRTTPS.)

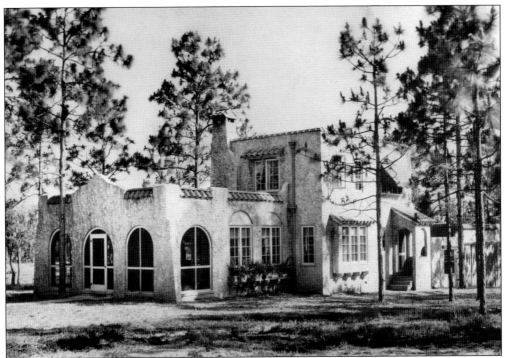

The George V. Booker House at 310 Glen Burnie Avenue was designed by architect M. Leo Elliott and is one of the few residences in Temple Terrace to incorporate elements of three architectural styles—Mission Revival, Mediterranean Revival, and Craftsman. Built in 1922 to 1923, it is also one of the few homes in the city to have its own stables in the backyard as well as a partial basement. (TTPL.)

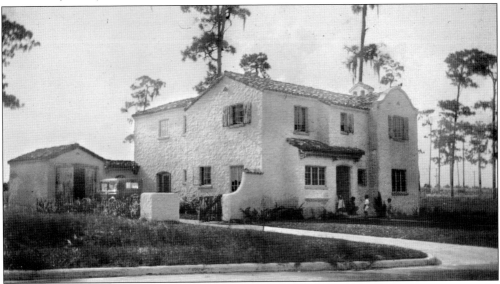

Built in 1926, the residence at 304 Brentwood Drive was designed by Dwight James Baum. Like other Baum models, this structure includes features such as ornamental tile fireplaces, solid bronze window screens, and stucco adapted from adobe homes in Mexico and Arizona. When new, the home sold for between $17,000 and $25,000. Its twin is located at 228 Willowick Avenue. (JC.)

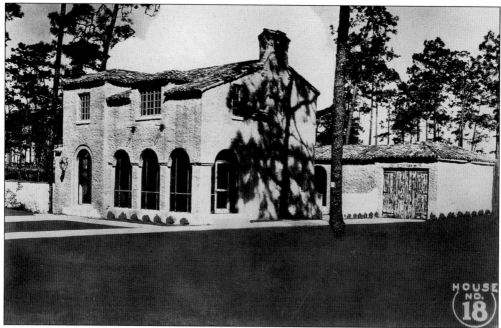

A page from the plan book that was created for all the homes designed by Dwight James Baum features House No. 18, the Renick House, at 404 Park Ridge Avenue. Buyers could select any plan from the book, but only one of each was allowed in each development section. Most of the plan book houses have twins. (Photograph by Burgert Brothers; JDR.)

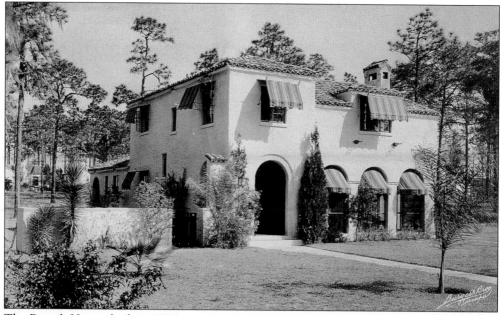

The Renick House, built in 1926, sat vacant until the early 1930s, when it was purchased by R. B. Renick. This photograph shows the addition of colorful, striped awnings. In 1986, a two-story addition was built onto the west side, and in 2001, Tampa architect Roger Grunke redesigned dining room windows, reopened a front porch that had been enclosed, and created a landscape design for the grounds and fountain. (Photograph by Burgert Brothers; JDR.)

Helen Renick and four children in costumes pose for a snapshot behind the family Cadillac, providing a glimpse of life on a typical Temple Terrace street during the early 1930s. Visible is the Renick home at 404 Park Ridge Avenue and another house beyond at 408 Park Ridge Avenue. In 1939, only 35 families lived in Temple Terrace. (JDR.)

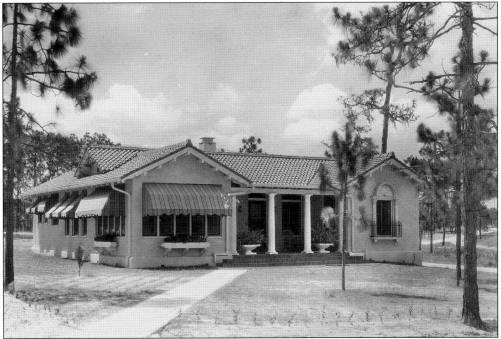

The Burks Hamner House at 212 North Glen Arven Avenue was one of the first seven houses built in Temple Terrace. Shown here on August 3, 1925, it was constructed in 1922–1923 for Burks L. Hamner, a city developer. Architect M. Leo Elliott designed the H-shaped plan around an open courtyard. Hamner later sold the home to Maud Fowler, and it became the center of political activity in town.

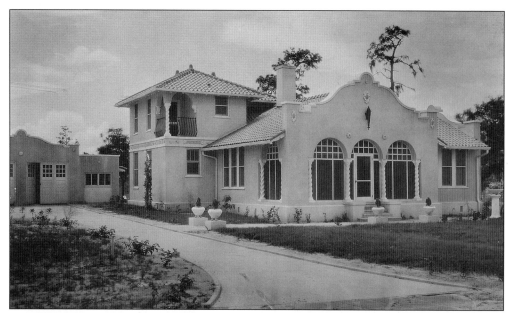

The Van de Venter House was designed by architect M. Leo Elliott for Rev. J. W. and Carolyn Van de Venter. The home at 208 North Glen Arven Avenue was one of the first built in the community in 1922 and was also one of the largest. It looks remarkably the same today as when this photograph was taken on May 12, 1923. Carolyn Van de Venter was city treasurer from 1934 to 1946.

Built in 1926, this Mediterranean Revival bungalow features an unusual Colonial front porch. Architect Dwight James Baum was known to favor Colonial Revival design. The home at 421 Bannockburn Avenue is typical of the smaller Spanish bungalows of about 1,400 square feet that did not have servants' quarters but did have detached carriage houses in the rear yard. The house was severely remodeled in the 1960s and has lost its historic significance. (GRTTPS.)

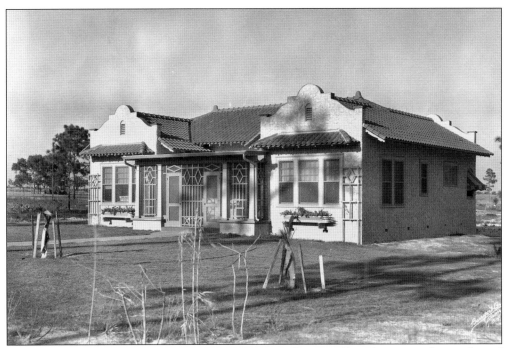

Architect M. Leo Elliott designed the house at 319 Sleepy Hollow Avenue with two shaped parapets on the front—similar to his treatment of the Temple Terrace Country Club clubhouse. Built in 1922–1923, this residence shares a distinctive H-shaped floor plan (featuring front and rear courtyards) with the Campbell-Smith house across the street at 322 Sleepy Hollow Avenue.

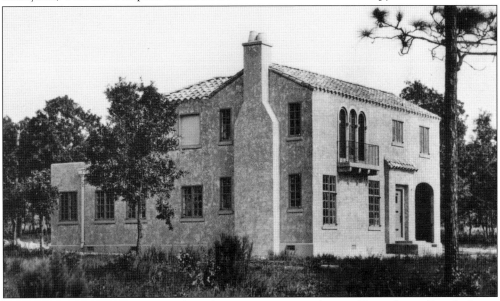

The Jim Barnes House, at 105 South Lockmoor Avenue, was designed by architect Dwight James Baum and was the residence of Temple Terrace Country Club golf pro "Long Jim" Barnes. Built in 1926, it features an open covered porch and a tripartite window and door opening that leads to a balcony with wrought iron railing. Its twin is located at 318 Sleepy Hollow Avenue. (Photograph by Burgert Brothers; TTPL.)

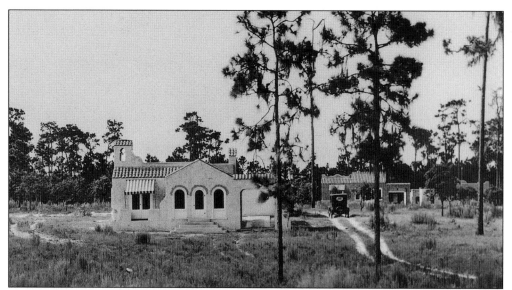

In the Spanish bungalow section of the city, the house seen in the center under construction is located at 319 Belleview Avenue and was designed by architect Dwight Baum. The houses in this area were smaller and lacked servants' quarters but did have detached carriage houses. The longleaf pine and wiregrass ecosystem still existed in 1926, as can be seen here. (Photograph by Burgert Brothers; TTPL.)

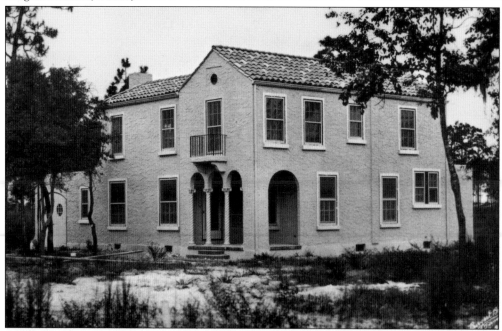

The John Perry House at 215 Willowick Avenue was designed by Dwight James Baum and built in 1926 by Bing and Bing Construction from New York. Each Baum-designed dwelling was distinct—with patio fountains and separate garages with adjoining maids' quarters—and used the best materials from around the world—cement imported from Belgium, steel casement windows from Spain, window glass from Germany, and tile from Mexico. (Photograph by Burgert Brothers; TTPL.)

A 1926 Temple Terrace scene is buzzing with activity with numerous homes under construction. This view, looking northeast toward Glen Ridge Avenue from the south end of Bonnie Brae Park at Bonnie Brae Boulevard, reveals a landscape of pine trees and sandy soil and a paved road. Park Ridge Avenue and Forest Park Avenue can also be seen in the distance. (GRTTPS.)

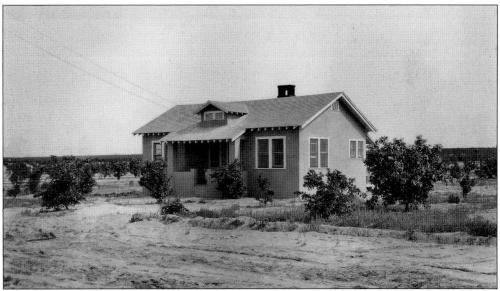

The cottage of Graham Phelps, a Temple Terrace grove superintendent, was located on the north side of Druid Hills Road (unpaved at the time of the photograph in the 1920s) and sat in the midst of 5,000 acres of temple orange groves. Every 1,000 acres of trees was overseen by an expert superintendent and team of skilled workers under the strict guidance of Buckeye Nurseries. (Photograph by Burgert Brothers; GRTTPS.)

At five years old, these temple orange trees are heavy with fruit and appear to be healthy and well cared for. The potential for the 5,000 acres of trees planted in Temple Terrace was enormous, given that one orange tree located nearby (said to have been 100 years old) was known to have produced 10,200 oranges in a single season. And, according to an advertisement that ran in the *Tampa Morning Tribune* on January 20, 1921, the fruit had sold the previous year on the Boston auction for $27 per box. The views of miles and miles of undulating rows of orange-bedecked, leafy green trees were unrivaled anywhere and became a draw for tourists, potential purchasers, and celebrity visitors alike. Even renowned athletes like Red Grange savored the opportunity to motor out to the groves and pick the beautiful fragrant fruit directly from the trees. (Photograph by Burgert Brothers; FFA.)

Jack M. and Alice Bregar pose in front of their home at 213 Greencastle Avenue on November 18, 1930. Between 1929 and 1942, Bregar, known as "Mr. Temple Terrace," served as judge, commissioner, mayor, and chairman of the planning and zoning commission. He later wrote a series of newspaper articles chronicling the history of Temple Terrace. *Out Of The Past* became the basis for a 1975 book written by Cleo N. Burney, *Temple Terrace: The First Fifty Years.*

From left to right, county commissioner G. Frank Bullard, Temple Terrace city commissioner E. A. McCartney, and City of Tampa superintendent of parks B. F. Sanborn are on hand for the groundbreaking of the Garden Club Highway Beautification project. Because of Bullard's efforts and contributions of trees and labor, the landscaped section of Temple Terrace Highway was dedicated as the G. Frank Bullard Parkway in January 1949. (GRTTPS.)

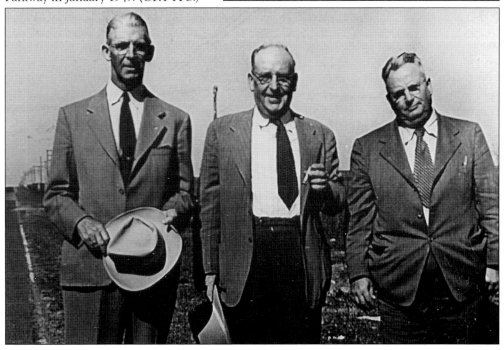

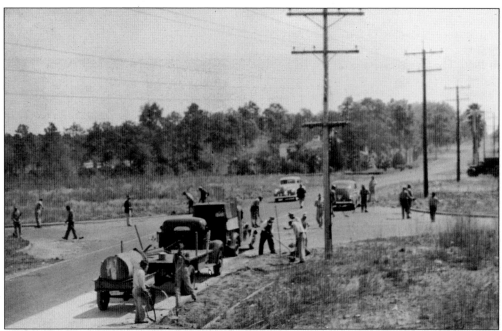

In 1939, as part of the Temple Terrace Garden Club Highway Beautification project, county trucks arrive to set out trees along Temple Terrace Highway from Fifty-Sixth Street to the Hillsborough River bridge. Commissioner G. Frank Bullard arranged for the donation of Washingtonian palms and magnolias as well as fertilizer. This view of the intersection of Fifty-Sixth Street and Temple Terrace Highway reveals that the temple orange trees that once were planted almost up to Ridgedale Road on either side of the highway had long since disappeared. A section of Temple Terrace Highway was renamed after Bullard in January 1949 to commemorate his road improvement efforts. In the image below, in the right foreground, is what appears to be the foundation of a demolished structure. The McCauley house can be seen in the distance. (Both, JDR.)

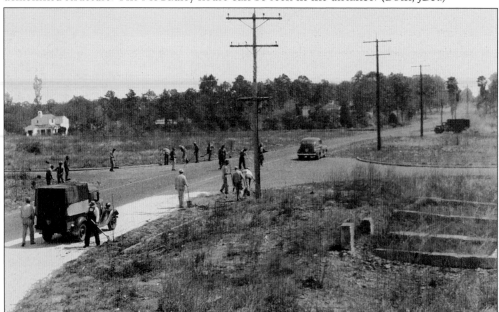

A wooden bridge spans the Hillsborough River on Temple Terrace Highway, as seen at right in 1936. The first known use of the name for the river was on a British map drawn in 1769. At the time, the Earl of Hillsborough was Britain's secretary of state for the colonies and controlled pensions of the surveyors working in the American colonies.

County commissioner G. Frank Bullard Sr. was responsible for having this old bridge over the Hillsborough River repaired in the late 1940s. The section of Temple Terrace Highway from Fifty-Sixth Street to the bridge was renamed as the G. Frank Bullard Parkway in 1949. Seen in the photograph below in 1954, it was replaced in 1955 with a concrete structure. (FSA.)

As the Great Depression lingered, bonds were issued to raise operating funds during Temple Terrace's struggle to survive. When the city could no longer pay the interest due on the bonds, agreements were reached with bondholders, who agreed to accept one-quarter of the original value as payoff. In order to come up with the amount needed for this settlement plan, a group of residents agreed to provide the funds in exchange for receiving city lots of their choosing. At a formal celebration on December 21, 1940, Temple Terrace residents gather in the Club Morocco ballroom for a ceremonial bond burning, jubilant that the city's heavy debt had been wiped out. Jack Bregar, "Mr. Temple Terrace," who served at various times as city judge, mayor, and commissioner, is shown below setting fire to Park Improvement Bond No. 23. (Both, JC.)

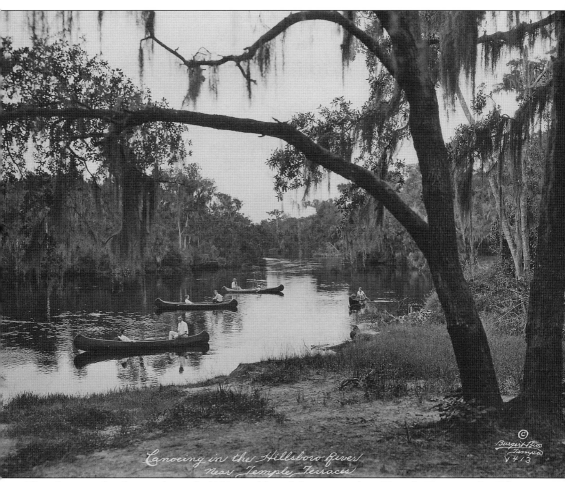

Canoeing in the Hillsboro River
near Temple Terrace

© Burgert Bros
Tampa
V 413

This photograph taken in the early 1920s could easily be a scene from Temple Terrace today. The identity of the city has been closely aligned with the Hillsborough River from the very beginning, and the waterway has been a steady influence amid the upheavals the community has encountered. But the river has its own separate history and has seen turbulence of its own—from the rich old-growth forests in the riverine swamps where cypress trees more than 3,000 years old were felled and the ecosystem changed forever to more recent stresses from human interactions. It could be said that Temple Terrace has similarly experienced highs and lows, from the 1920s through the Great Depression up to today. The devotion of its residents has always proven powerful enough to sustain and propel the city onward in constant renewal, just like the river that winds its way so elegantly through and around the city and beyond.

www.arcadiapublishing.com

Discover books about the town where you grew up, the cities where your friends and families live, the town where your parents met, or even that retirement spot you've been dreaming about. Our Web site provides history lovers with exclusive deals, advanced notification about new titles, e-mail alerts of author events, and much more.

MADE IN THE USA

Arcadia Publishing, the leading local history publisher in the United States, is committed to making history accessible and meaningful through publishing books that celebrate and preserve the heritage of America's people and places. Consistent with our mission to preserve history on a local level, this book was printed in South Carolina on American-made paper and manufactured entirely in the United States.

This book carries the accredited Forest Stewardship Council (FSC) label and is printed on 100 percent FSC-certified paper. Products carrying the FSC label are independently certified to assure consumers that they come from forests that are managed to meet the social, economic, and ecological needs of present and future generations.

FSC
Mixed Sources
Product group from well-managed forests and other controlled sources

Cert no. SW-COC-001530
www.fsc.org
© 1996 Forest Stewardship Council

Find Your Place in History.